# JOYCE TENNESON

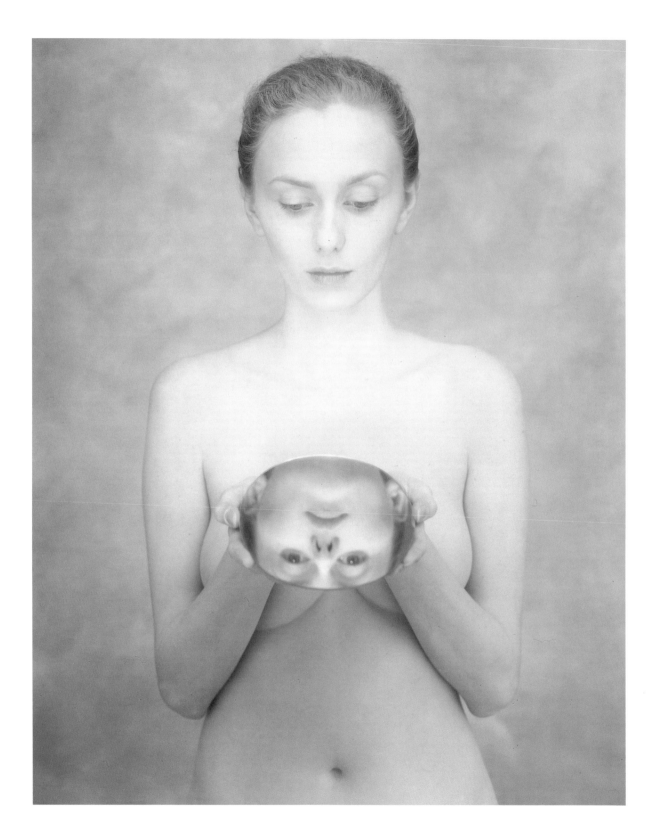

# JOYCE TENNESON

## TRANSFORMATIONS

INTRODUCTION BY
VICKI GOLDBERG

INTERVIEW BY
DAVID TANNOUS

A BULFINCH PRESS BOOK
LITTLE, BROWN AND COMPANY

BOSTON · TORONTO · LONDON

THIS BOOK WAS PUBLISHED WITH THE GENEROUS SUPPORT OF

EASTMAN KODAK COMPANY'S PROFESSIONAL IMAGING ORGANIZATION

First Edition

Library of Congress Cataloging-in-Publication Data
Tenneson, Joyce, 1945–
        Joyce Tenneson : color work / introduction by Vicki Goldberg;
    interview by David Tannous. — 1st ed.
                p.  cm.
        "A Bulfinch Press book."
        ISBN 0-8212-1933-2
        1. Photography, Artistic.  2. Tenneson, Joyce, 1945–.
    I. Tannous, David.  II. Title.
    TR654.T444   1992                              92-17813
    779' .092—dc20

Bulfinch Press is an imprint and trademark of Little, Brown and Company (Inc.)
Published simultaneously in Canada by Little, Brown & Company (Canada) Limited

Book design by Eric Baker Design Associates, Inc.
Printed and bound by Amilcare Pizzi, Milan, Italy

# ACKNOWLEDGMENTS

I would like to thank everyone who has been involved in the making of these images and this book. There are too many people to mention by name. You know who you are — I only hope you realize how grateful I am for your many contributions to my life and my art.

I dedicate the book to all of you.

# UNWRITTEN MYTHS

## VICKI GOLDBERG

The little girl in the photograph, posed like a supplicant, is singularly
beautiful. Her hair is luxurious and curly, her skin flush with life. The old
man beside her turns his back and will not pay attention; his flesh is so
bloodless he might be receding physically as well as emotionally. The child's profile has
produced a dim double image of itself, perhaps an index of the intensity of her yearning,
and she comes equipped with wings — but the wing we see is gray and ribbed like a bat's,
as if this angelic and neglected creature were somehow in league with the dark.

Joyce Tenneson's world quietly, frequently, composes itself around dualities: angel and
menace, childhood and age, beauty and sorrow, naked and veiled, earthy and ethereal.
Religious references and sensuality merge in some muted state in her work — in one
photograph, a young woman wrapped in the sheerest gauze wears a hat that resembles a
nun's cowl pulsating with light; in another, a young woman's naked buttocks give the
camera a splendid view of female flesh, but her upper body is obliterated by a great
diamond-shaped patch of brilliant white, like wings woven of an unearthly radiance.

Tenneson grew up on the grounds of a convent where her parents worked for the nuns; she
and her two sisters donned wings to play angels in the Christmas pageants and wore white

gowns and flowers in their hair on May Day. The caps that occasionally hide the hair of her models and the heavy bodies of some of the older women, the hushed and solemn ritual air in many of the pictures give off faint echoes of convent life. Caught in a stasis as profound as meditation, the nude and semi-nude bodies are like the final answer to a child's deep imaginings. The varied shapes and states of the human form are covered but not hidden by thin veils, a kind of reminder of the veils of custom, limit, and discretion that obscure so many mysteries when we are young (and when we are not so young as well). Tenneson's color work of the last six years has created a private territory somewhere between Catholicism and Freud.

Few women have photographed the nude body as consistently as Tenneson has (one thinks of the very different enterprises of Ruth Bernhard, Becky Young, and Anne Noggle), and she portrays pregnancy, the heavy flesh of middle age, and emaciated old age with grace, acceptance, and affection. The compelling photograph of a pregnant woman who regards the viewer with a combination of openness, self-assurance, and gravity was made for an editorial spread on fragrance in *Taxi* magazine. Tenneson suggested one page of the spread feature a pregnant woman; when the editors declined, she offered to shoot the picture at her own expense. The result was feminine in a way that rarely sees print, and the magazine ran the image.

Some of the pictures of young women are tantamount to nude portraits, the subjects openly confronting the camera and the viewer. The success or failure of such images rides heavily on the exceptional and often unconventional good looks of what might be called Tenneson's repertory company of models. These are beautiful pictures of beautiful women with beautiful bodies, in an era when beauty has been so commercialized that artists and photographers approach it with wariness. And in fact the danger in work like this lies in slipping over the line of mere prettiness, which could happen simply because a model looks too much like the mannequins in so many ads and fashion magazines. For the most part Tenneson maintains her difficult balance, depending on her stubborn belief that even lovely women have inner lives, and her recognition that darkness can shadow the most lyrical human encounters.

Many of her images of brooding men and women and sober children subtly but unmistakably imply spiritual awareness and longing—not immensely popular subjects in the second half of the twentieth century. The search for transcendence with a camera, unfashionable in a secular climate and difficult in any event, has intermittently turned up in one guise or another throughout photography's history. Transcendental ideas in the photography of the last fifty years tend to be couched in terms of abstraction (Minor

White) or allegory (Clarence John Laughlin, Duane Michals) but seldom translated onto barely disguised flesh. Tenneson's work is more direct; it abounds with angelic presences who do not find it necessary to cover up. (Indeed, she lives with angels, most of them clothed: two books about them sit on her coffee table, and a sculpture of one, with a single blue wing, kneels on her floor.)

Her most recent pictures involve drawing with light in a medium already consisting of little else. (The word photography itself means writing with light.) Wands are composed of metal and streaks of brilliance, intertwined branches are haloed with purest incandescence, and a man's fists pour out blazes of light the instant he touches his chest. Yet this more-than-human luminescence is unmistakably bound to the things of this world and closely joined to some human reference: skin, body, breast, buttock, flank.

To find a comparable, if inverse, combination of sensuousness and otherworldliness one would almost have to go back to Julia Margaret Cameron in the third quarter of the nineteenth century. Cameron's subjects, all modestly dressed as became the local English gentry, posed for her camera as the holiest figures of the Christian story

(including angels, whose hair was sometimes lit with a dazzling light). Her Madonnas and angels were women of immense beauty, with masses of flowing hair and undeniable sensual appeal, and naked children more than once played the part of Cupid. She titled one picture of a woman and child *My Grandchild*, then took another of the same mother and child in nearly identical poses and called it *The Shadow of the Cross*, indicating that the common human experience could be very close to the divine.

There is no direct influence here, but the parallels say something about the nature of Tenneson's work and how far back its roots go. Tenneson's earlier black-and-white photographs had even closer ties to the past: permeated by nostalgia, they often focused on antique clothes, laces, and sentiment, gauzy overlays and draperies, and their wistfulness for an age they openly acknowledged had never been wholly innocent gave them an uneasy edge.

In her color work, she inclines toward classical, centered compositions, an air of measured calm, and a grave, sorrowful, restrained, and otherworldly delight in the body that would have suited the previous century perfectly were it not all so unashamed. The polarities multiply: a highly traditional, classicizing presentation, plus an interplay between body

and spirit so delicate as to hint of an earlier time, combine with a candor about nudity and a sense of psychological ambiguity that could scarcely have existed before.

It was during the nineteen seventies, when artists ranging from Lucas Samaras to Eleanor Antin were making extended records of their lives and bodies, that Tenneson began taking self-portraits and autobiographical photographs. For anyone who has followed her career, the color photographs seem like an oblique continuation of that examination of the self, a projection of memories, dreams, and emotions — she speaks of the picture of the old man and the child with the bat wing as being very much about herself—onto a symbolic stage. (All artists and "art" photographers do this to a degree; some are merely franker than others.)

It was also during the seventies that implied and indeterminate narrative grew popular with artists: single or serial images that told a story purposely left open-ended to be filled in by the viewer's own associations. On the heels of minimalism, site art, and non-figurative painting, artists like Ida Applebroog, Robert Longo, Nicholas Africano, and Cindy Sherman depicted incidents or moments that appeared to be full of meaning but were never fully explained. Tenneson does the same. When a heavy woman places her

hands on the shoulders of a submissive child, with a line of nudes standing in tight order behind them, the story lies wholly open to interpretation. Is the woman a nun, as some say? Are they all in a concentration camp, as others suppose? Or in some hushed purgatory of the mind, or some dream of an older generation quietly passing along the sad wisdom of life?

Tenneson began to use the 20 x 24 color Polaroid camera for her private work when that camera was first set up in New York in 1986. When she uses other equipment on commercial assignments or when her work is reproduced in other processes, her subdued, smoky pastels still glow, but the emphasis shifts away from their peculiar sense of autumnal haze and deceptively downy texture. Her color tends to ochres, grays, pale blues, and paler flesh tones, sometimes almost monochromatic, generally toned down, bleached, dusky. Backdrops are brushy, the atmosphere misty and stilled. Skin is powdered and fine nets thrown over bodies, until human beings take on the tonality of their surroundings.

Her portraits of children (and some of older people) are compellingly direct. Jessica Tandy, still elegant in her eighties in simple draperies lifted from some myth, plays

the role of a muse with an uncommon knowledge of life, and perhaps of the life to come. A blonde child in a white dress, holding a bouquet of dead flowers, has a more uncompromising stare, more power, and more sheer physical *presence* than it ought to be possible to pack into such a small frame.

Even as we watch, that child's bouquet is being transmuted into pure light. In a number of these pictures there is a sense of slow transformation in process, a state of becoming, and possibly of disintegration. It is most obvious where light obliterates form, but also seeps in where age and dream and atmosphere exert their pull. Figures such as the old man who ignores the winged child may seem like specters slowly emerging or disappearing, like the photographic image itself when it miraculously wells up into life in the developing tray or on the surface of the instant print, and then over time withdraws as the repeated action of light leaches it away. In utter stillness, the present imperceptibly seems to vanish, and solid bodies wait for one kind of future or another to consume them. An elusive myth wanders across these pictures; its subjects pause for a poignant moment in the flux of time.

# COLOR WORK

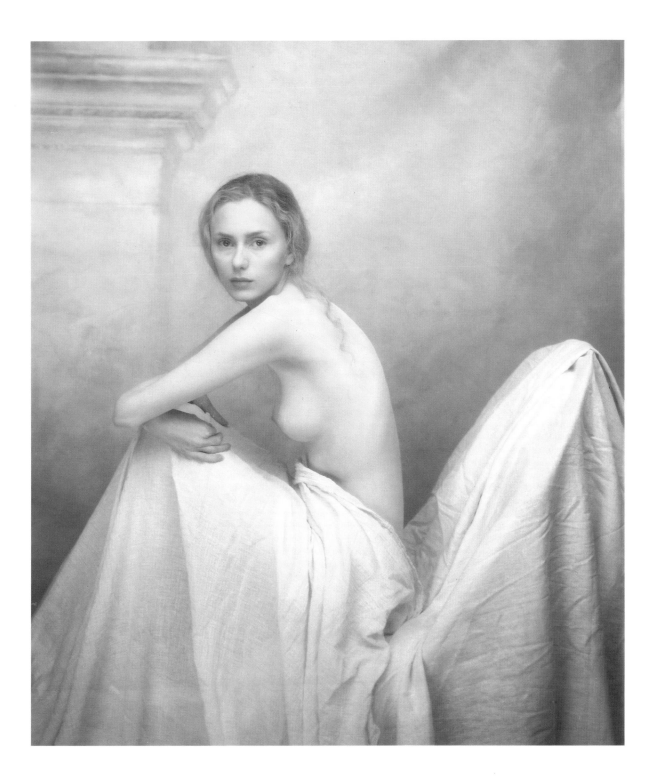

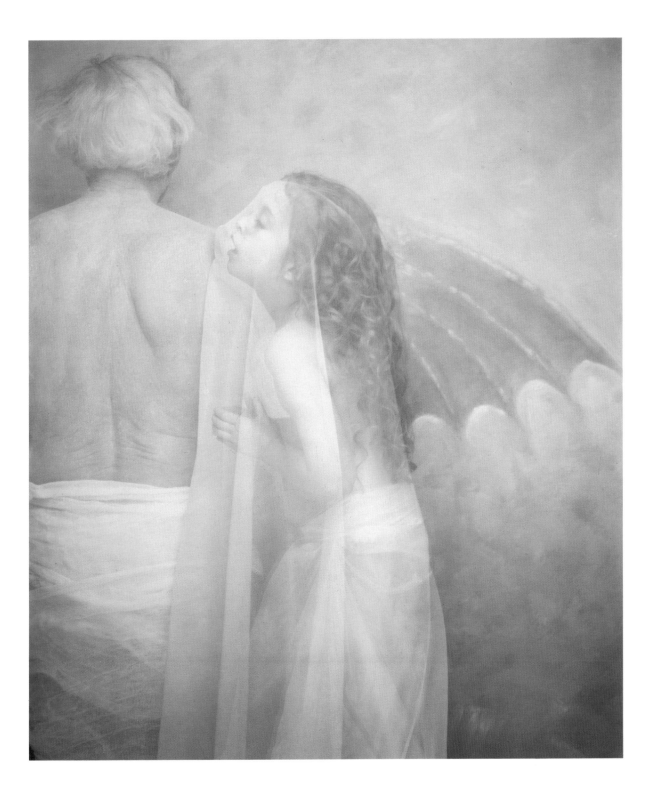

17

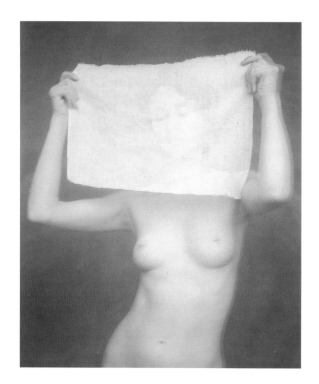

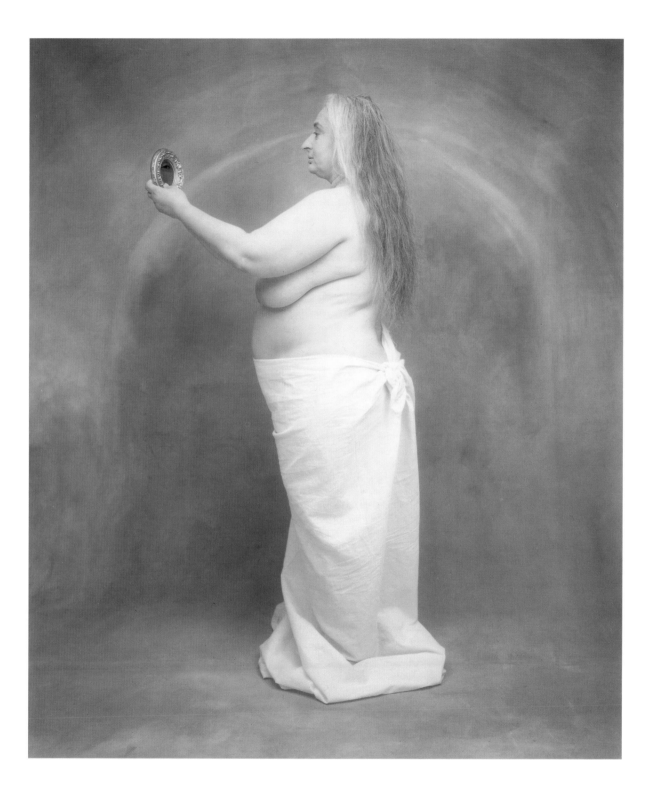

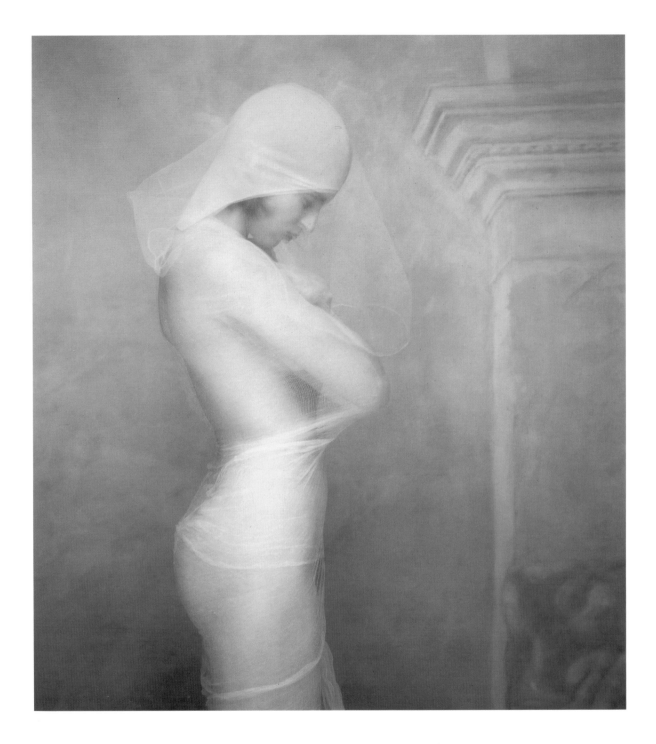

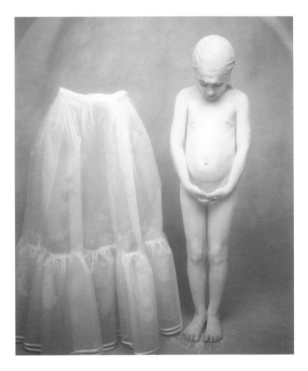

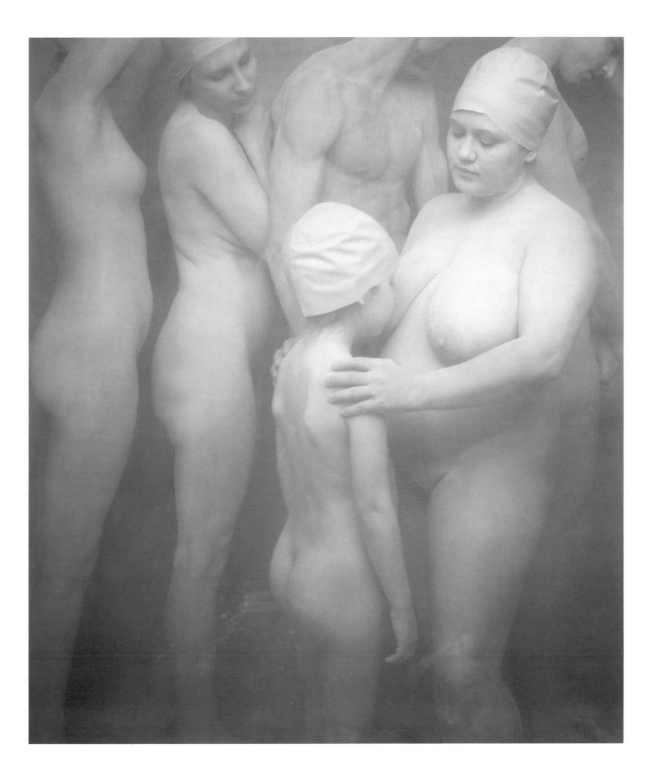

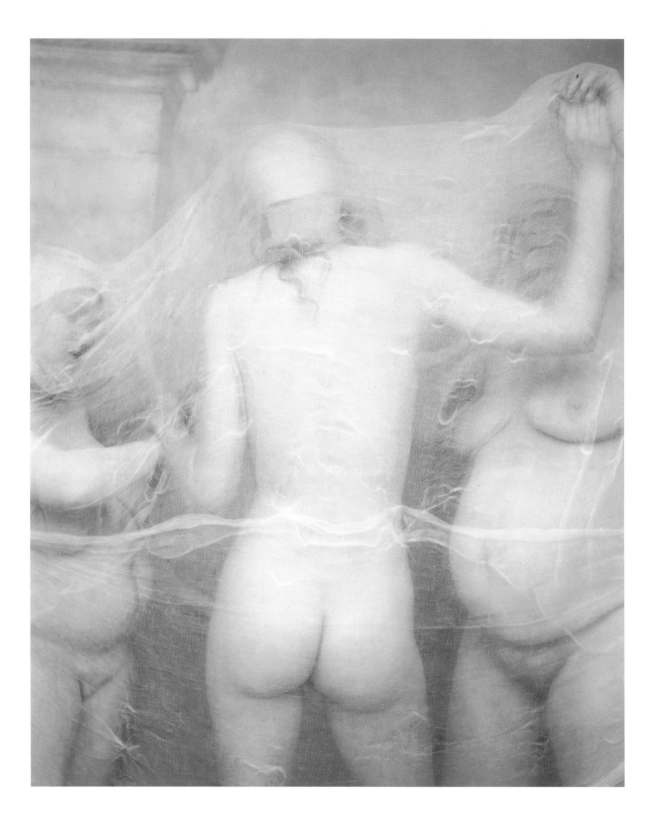

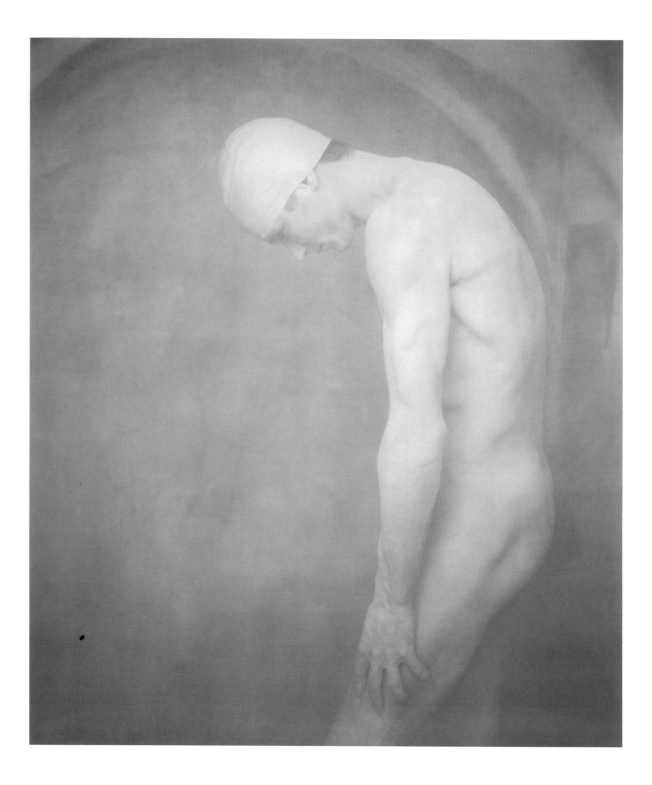

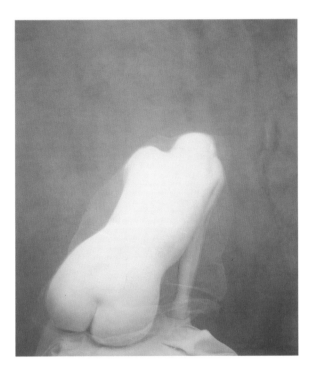 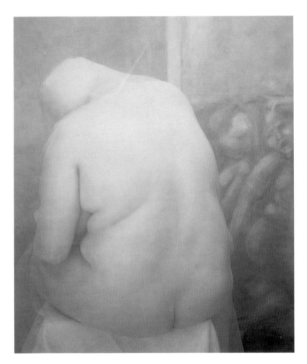

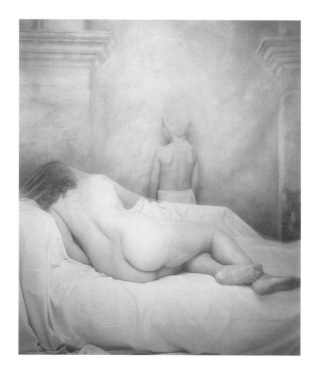

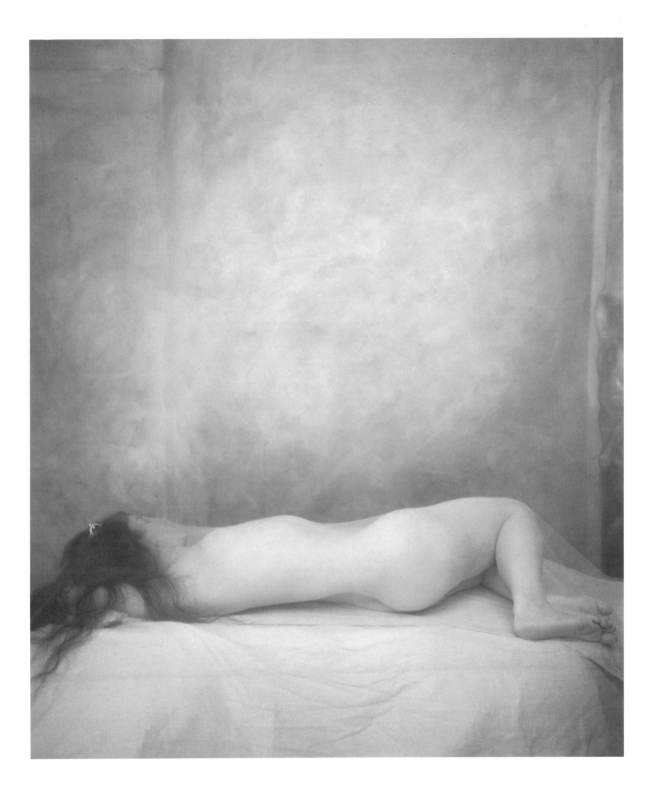

29

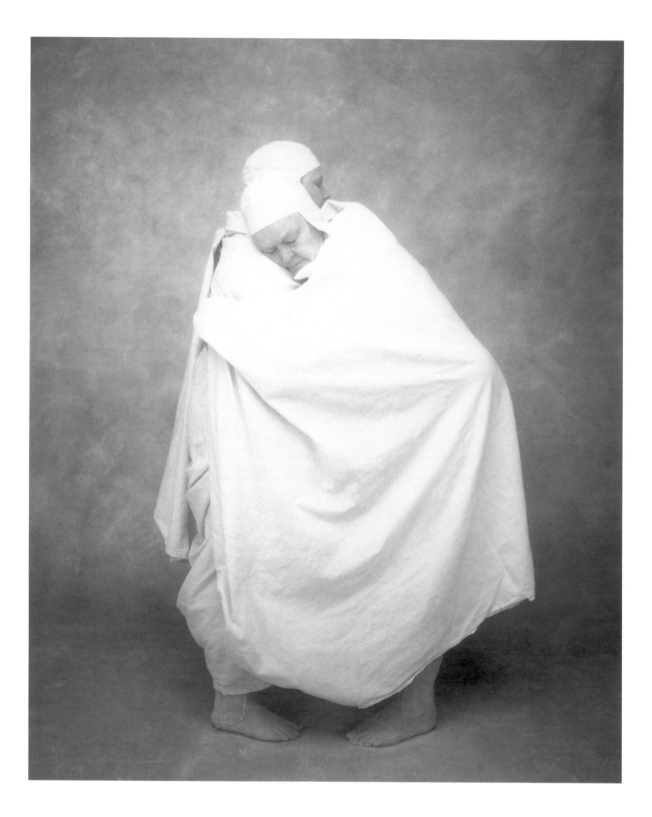

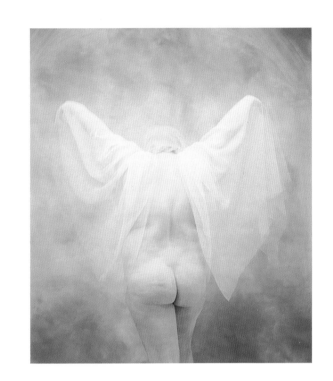

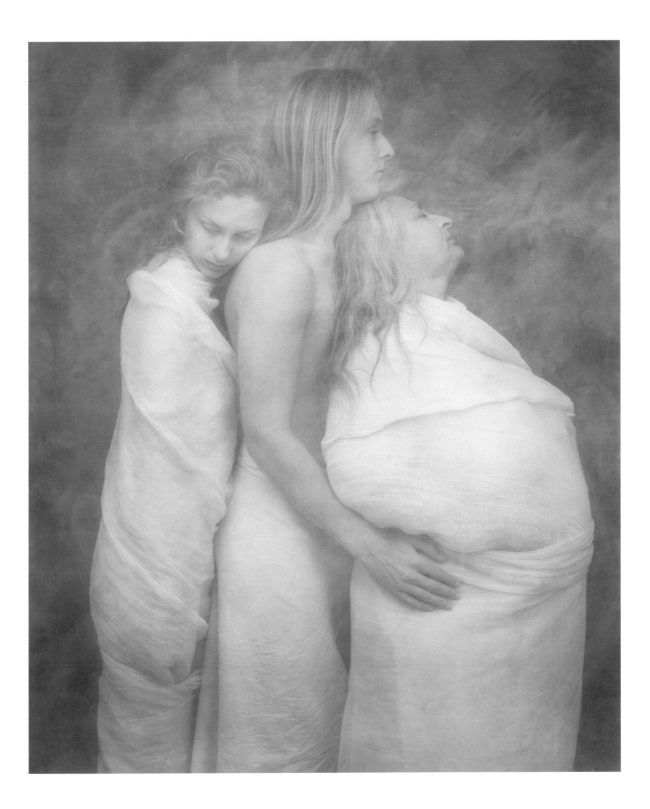

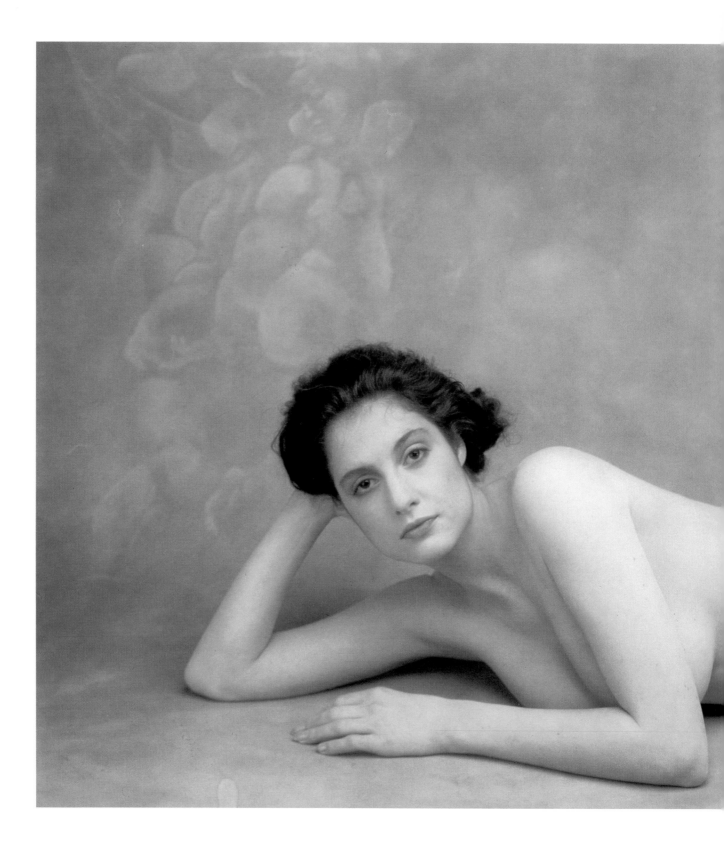

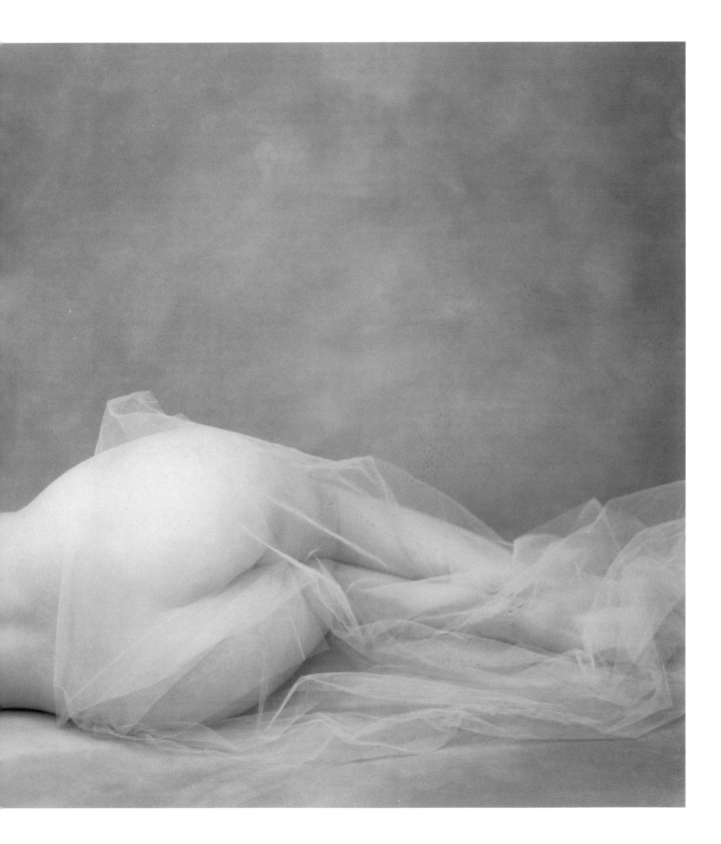

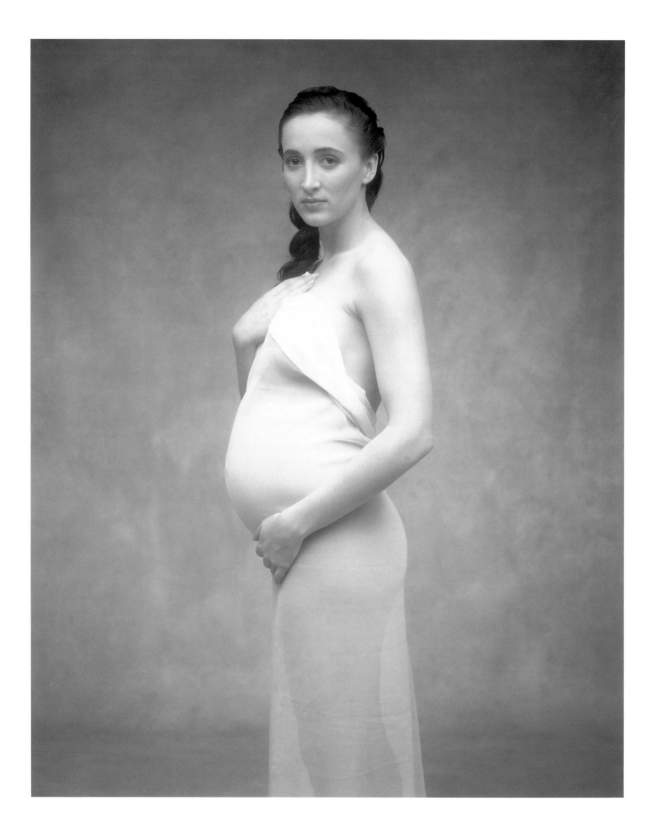

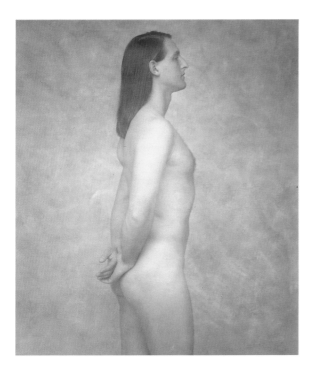 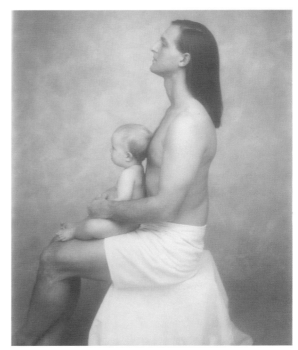

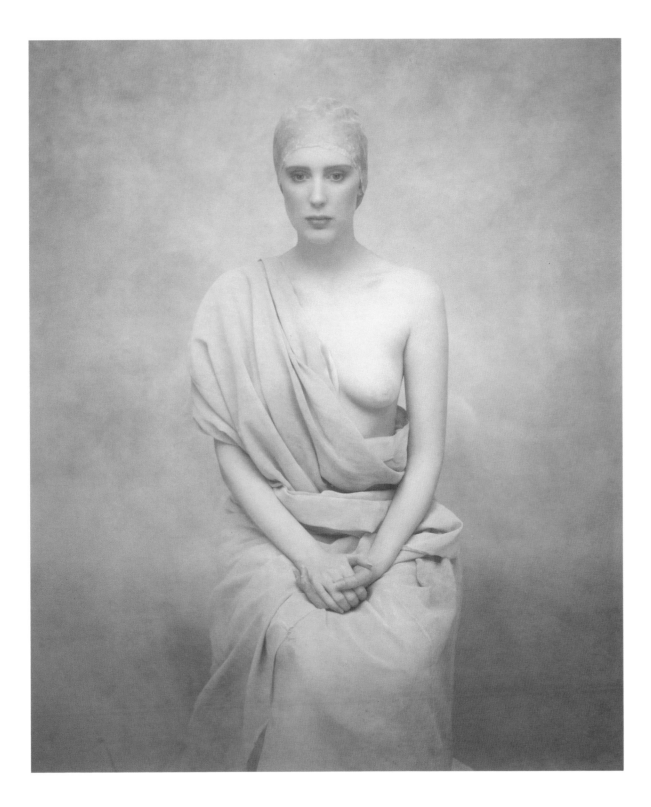

39

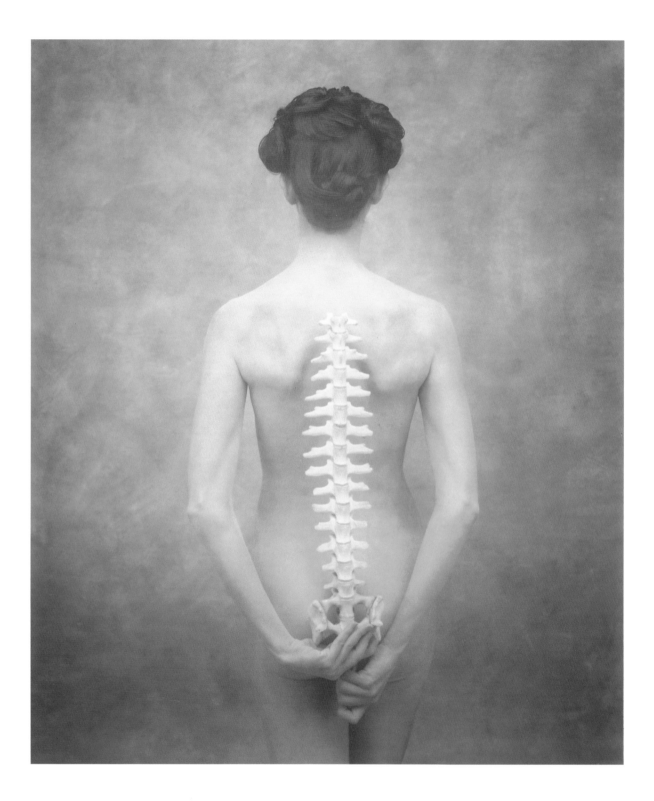

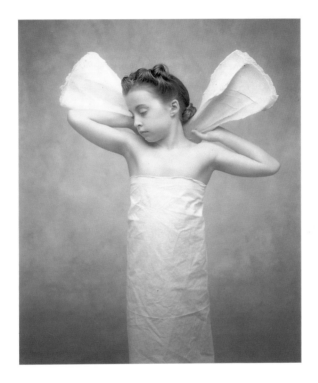

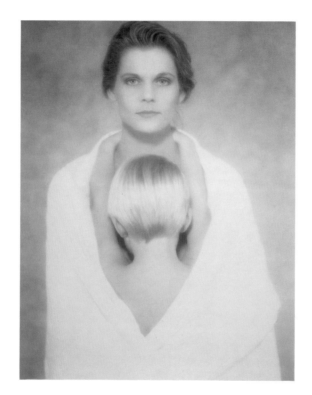

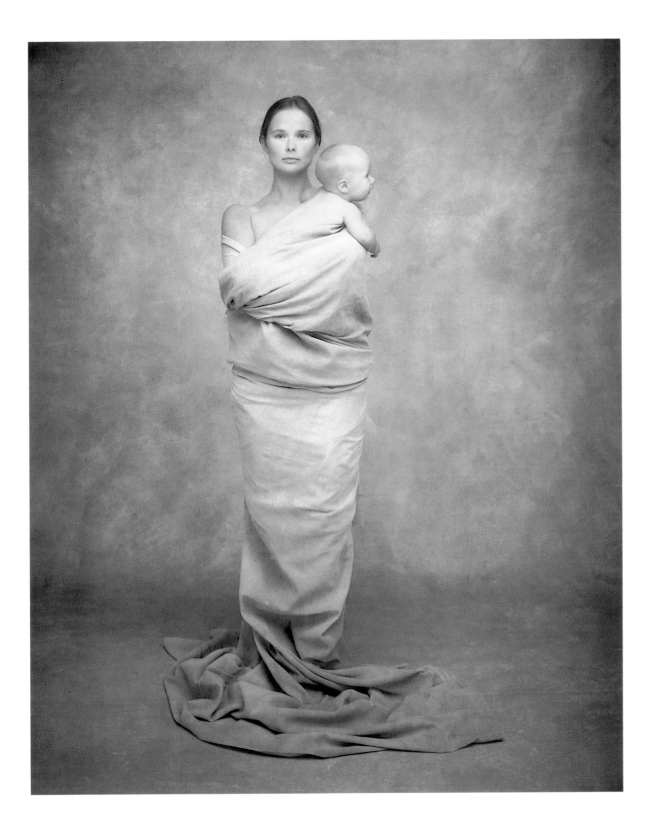

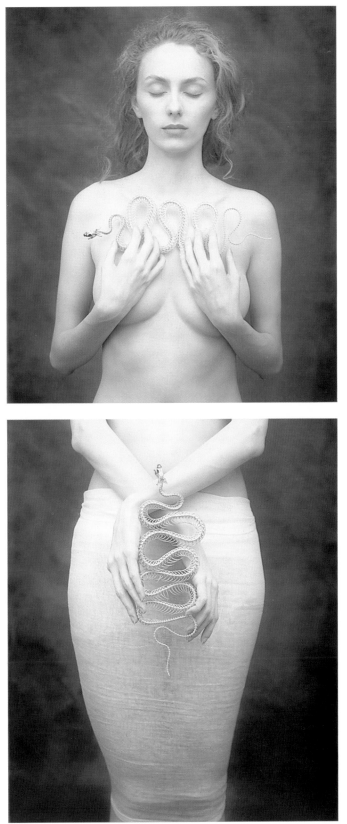

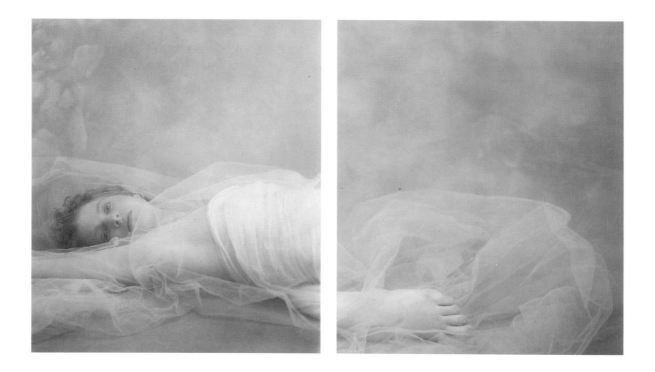

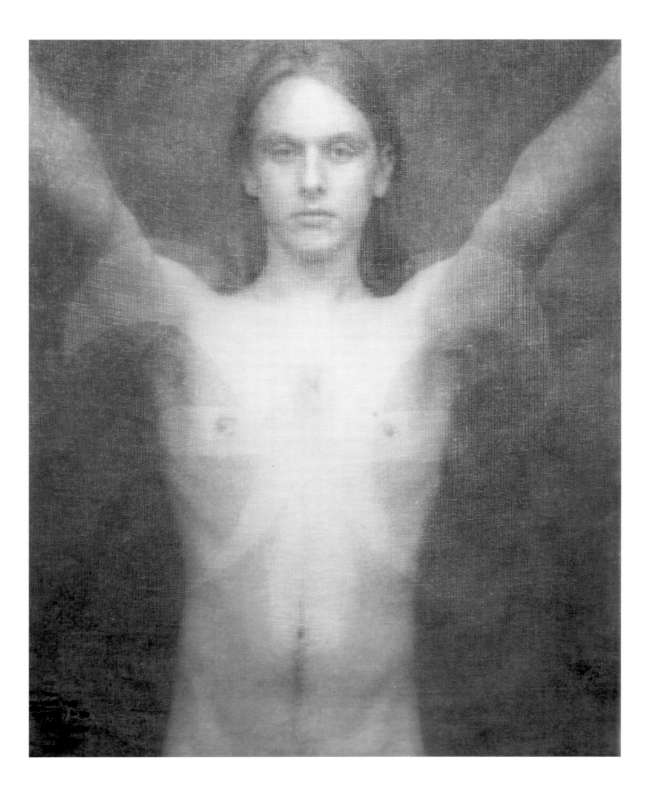

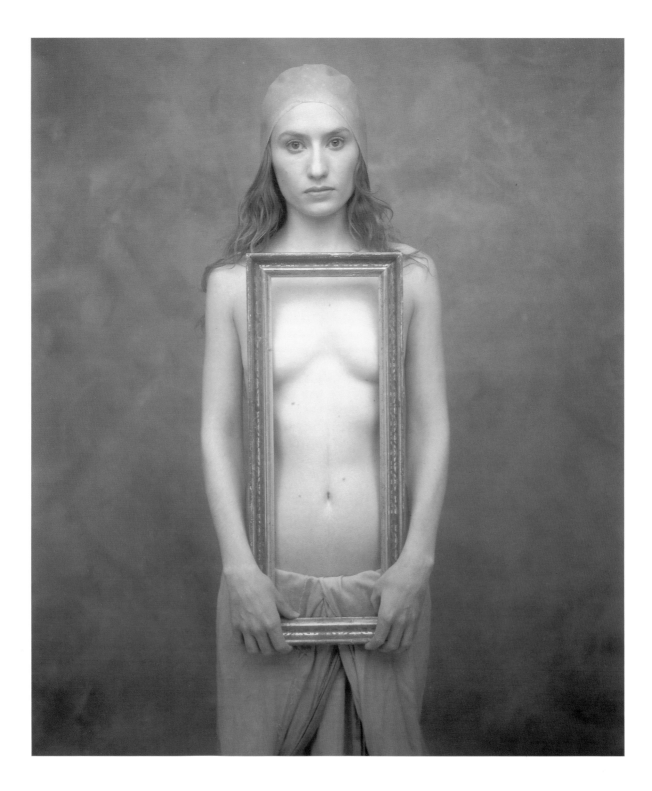

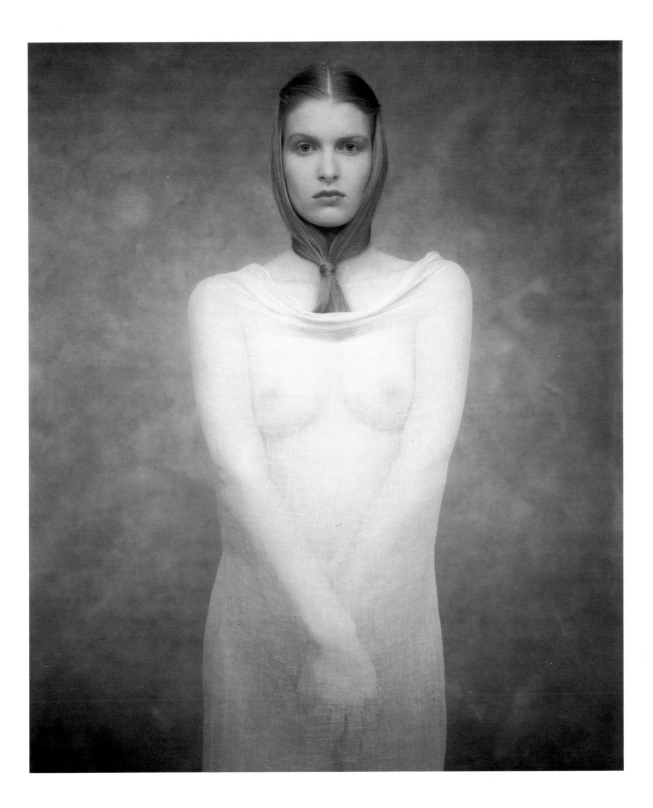

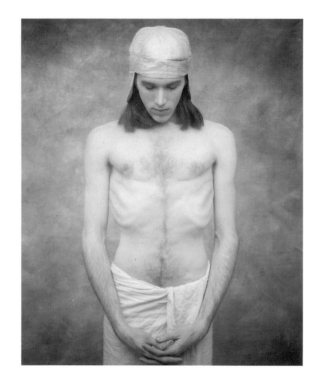

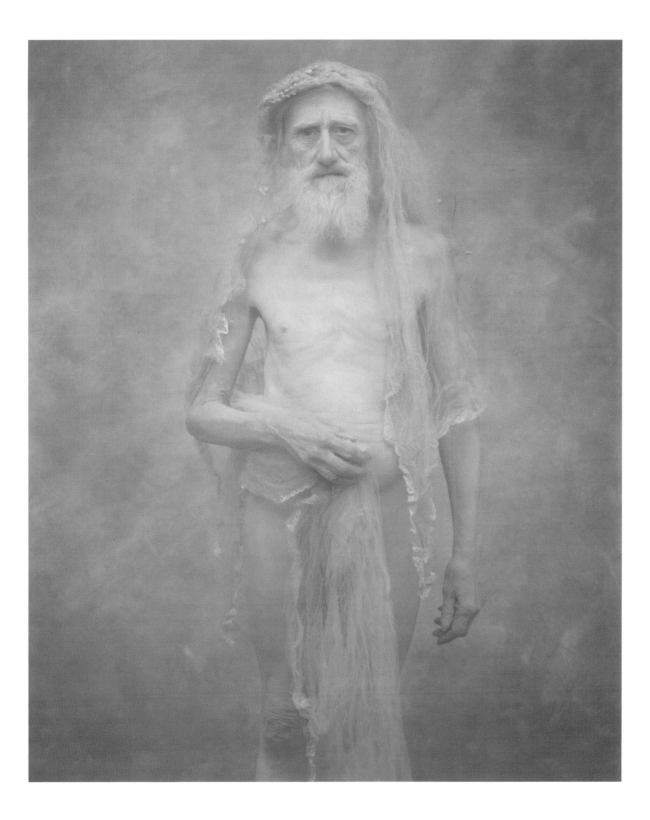

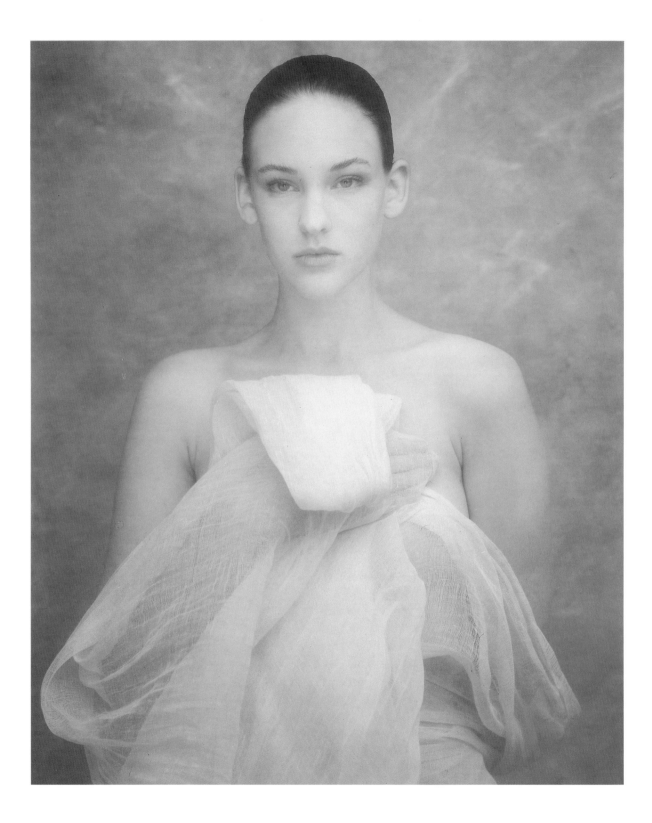

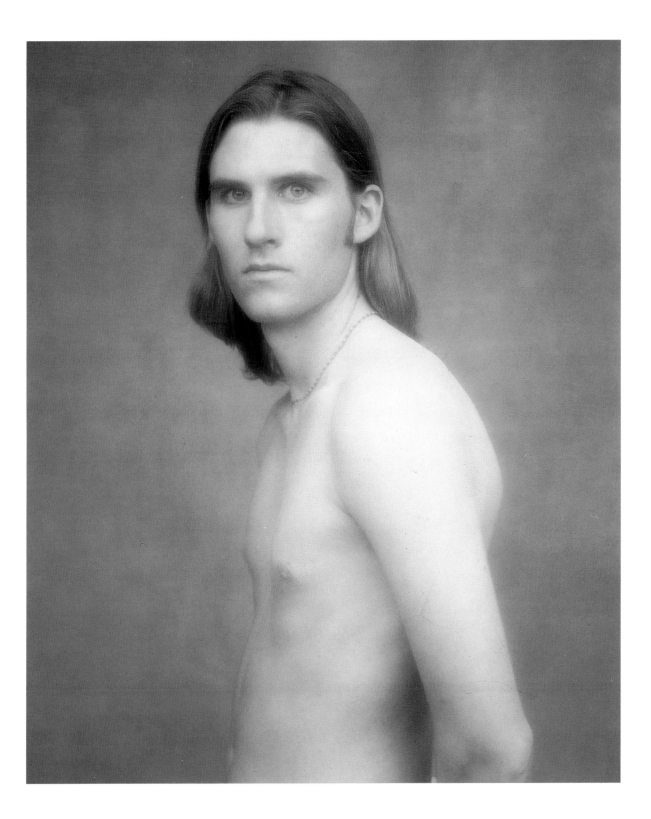

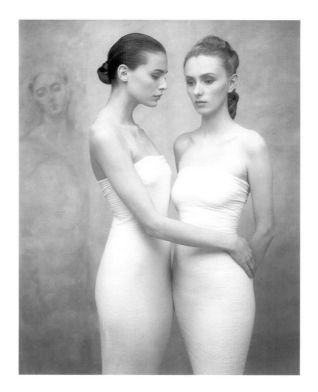

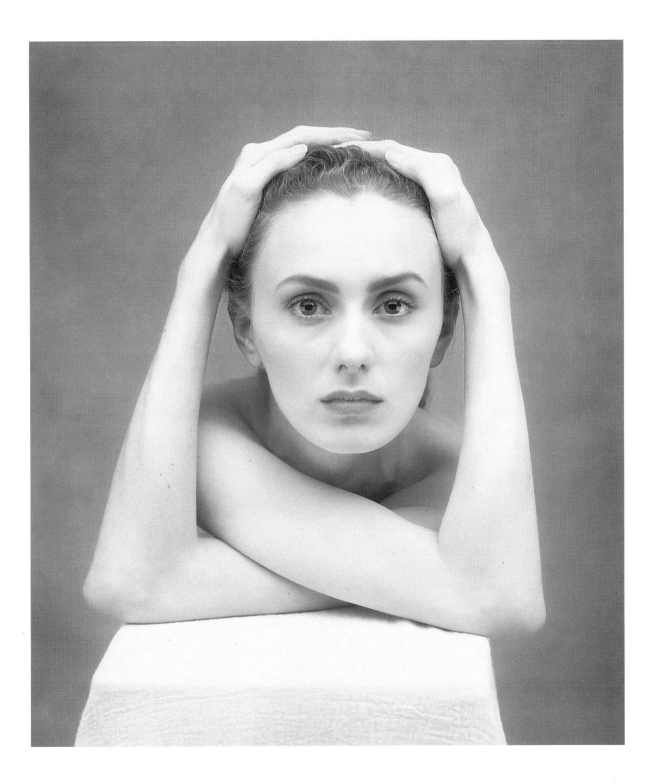

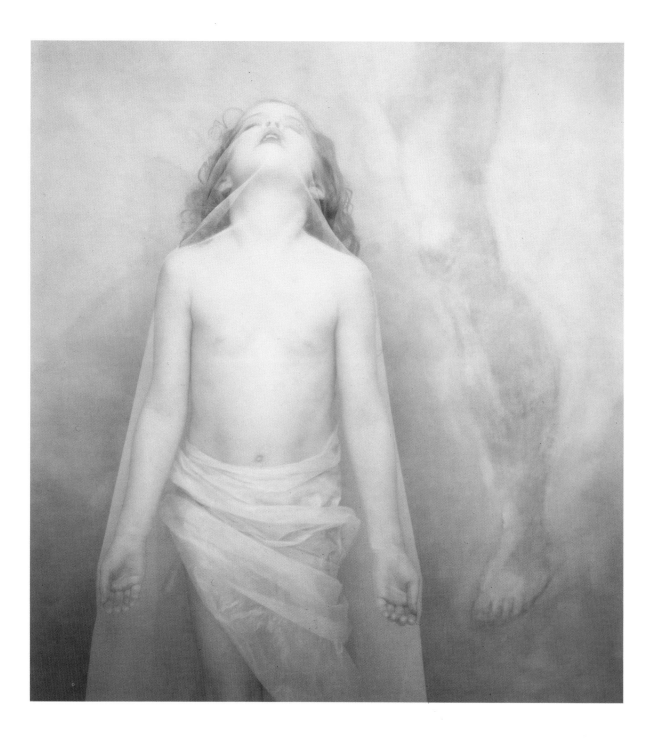

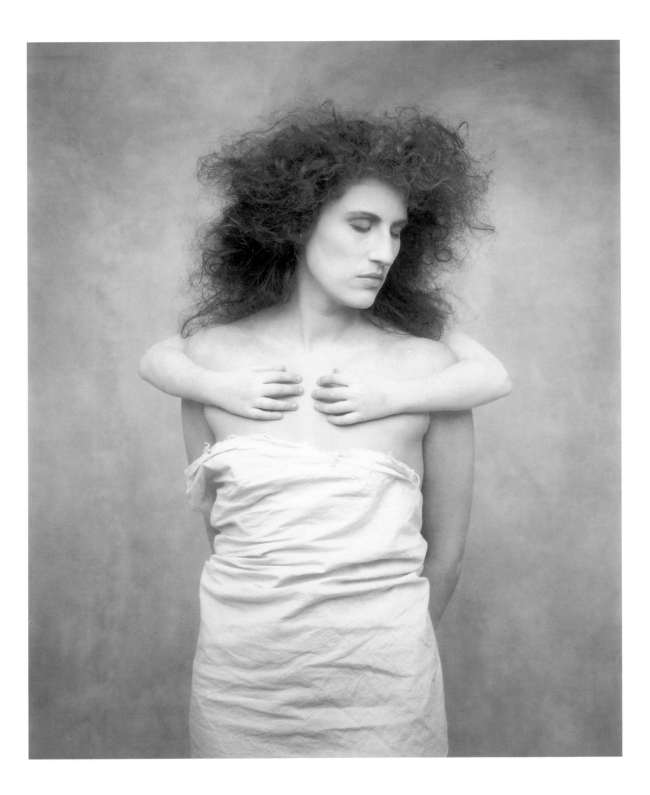

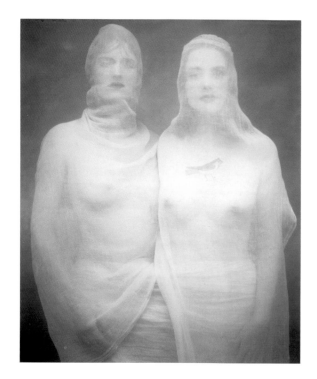

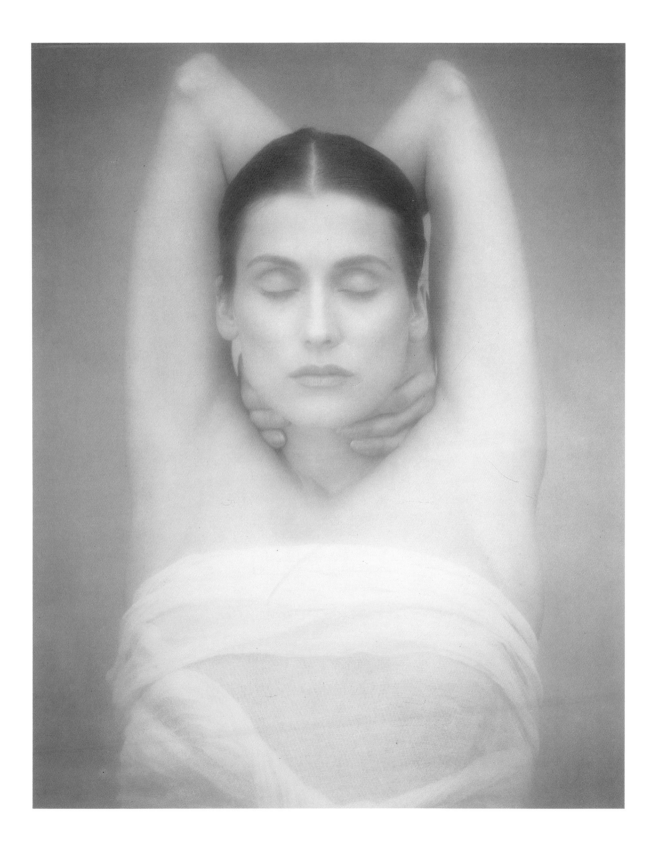

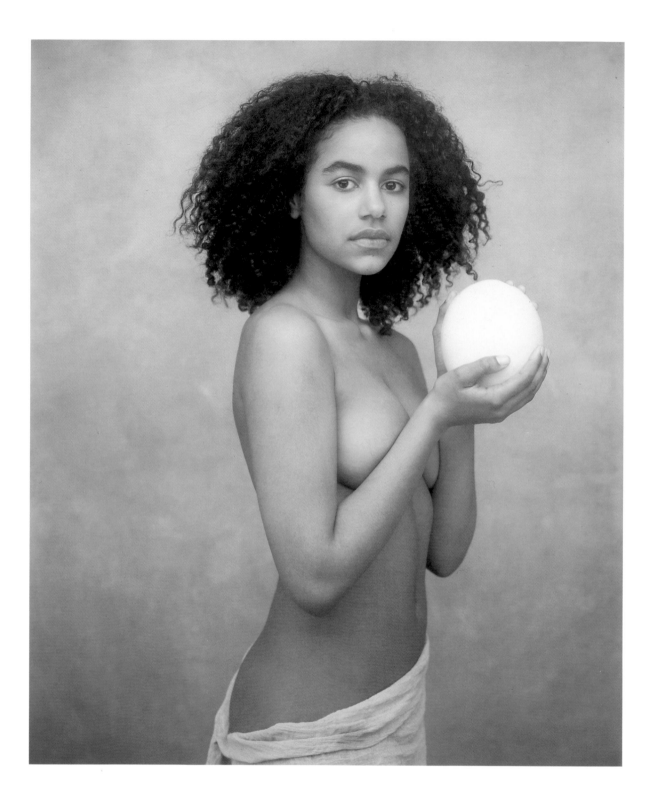

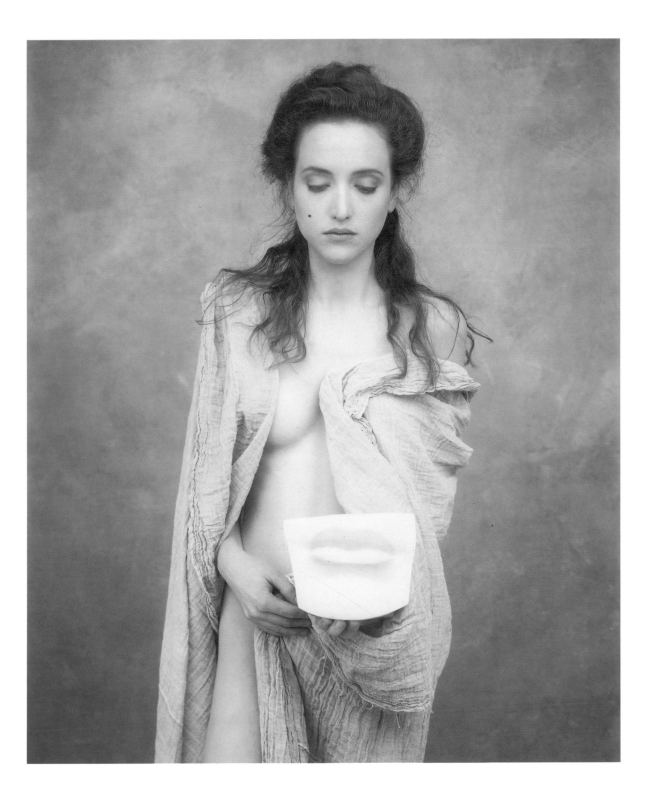

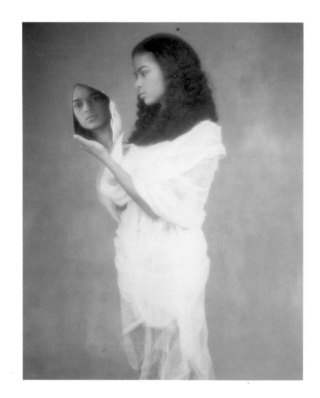

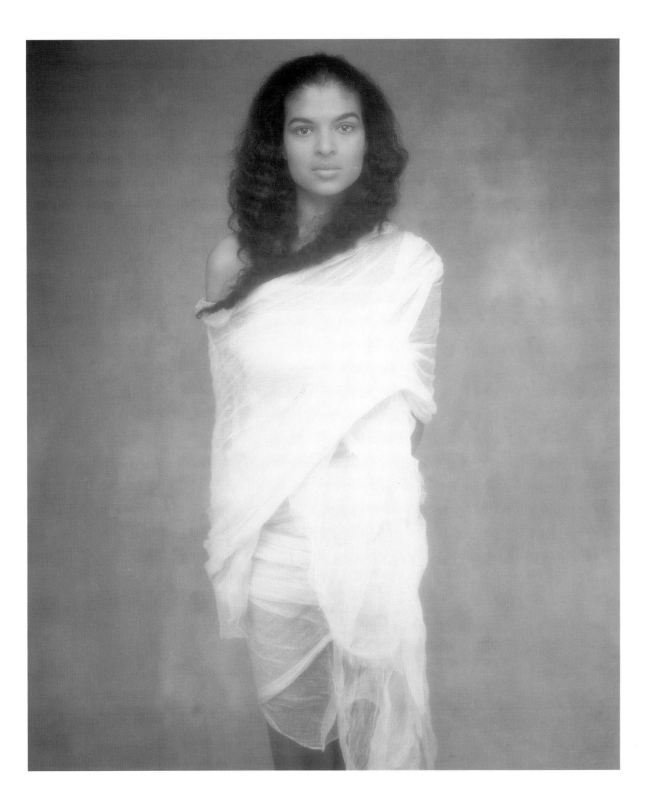

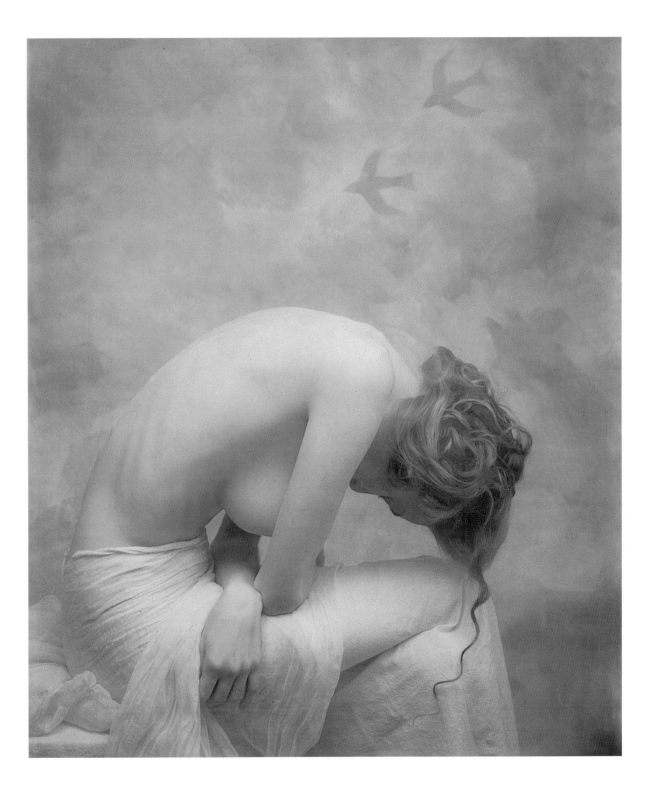

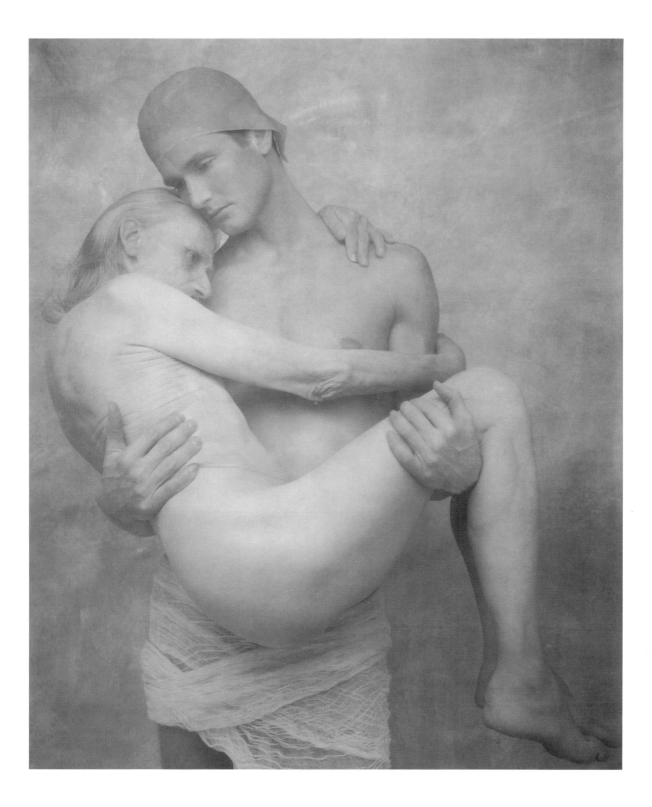

# LIGHT WRITINGS

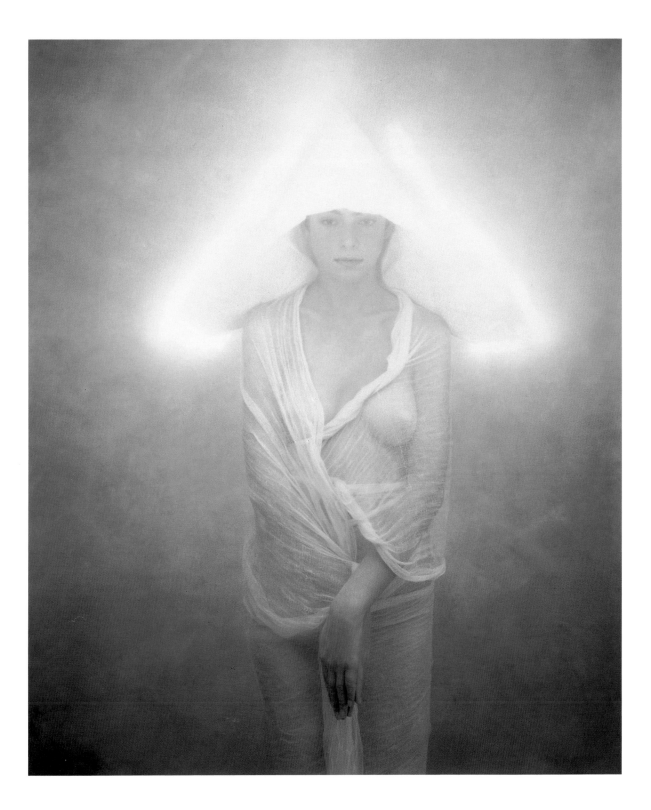

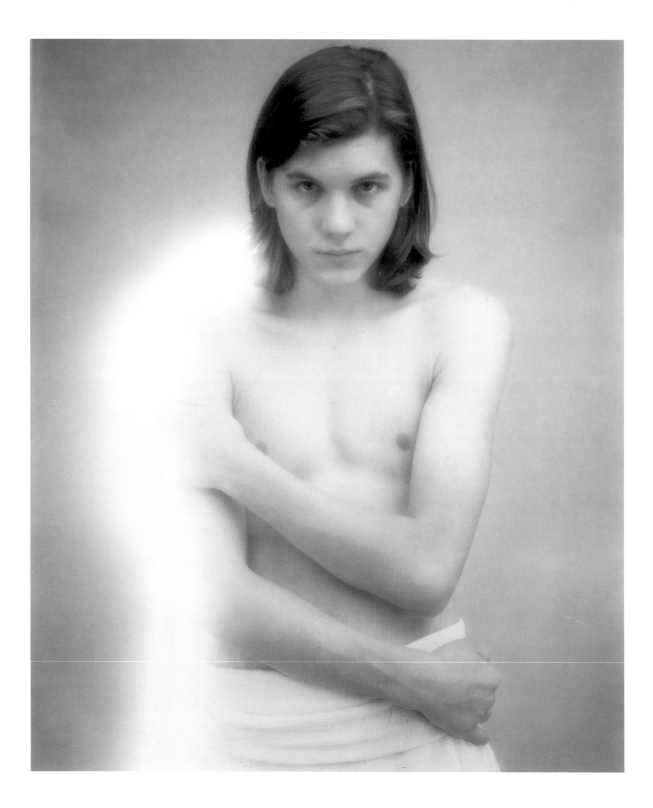

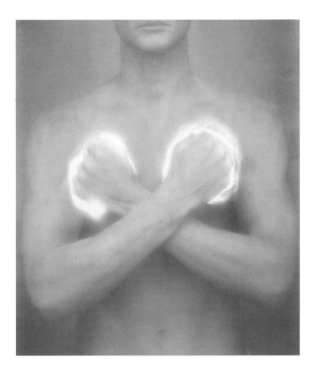 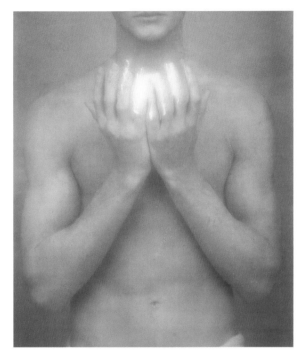

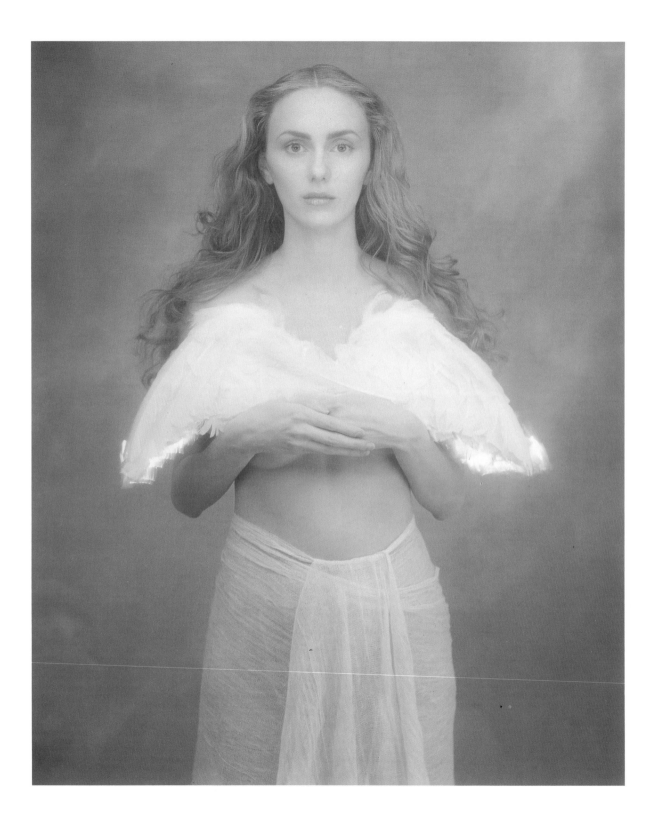

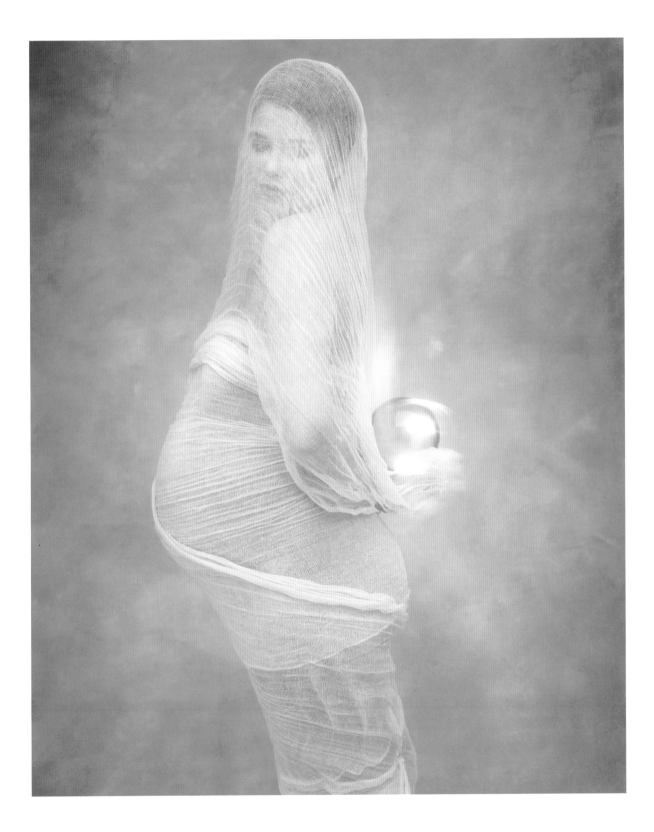

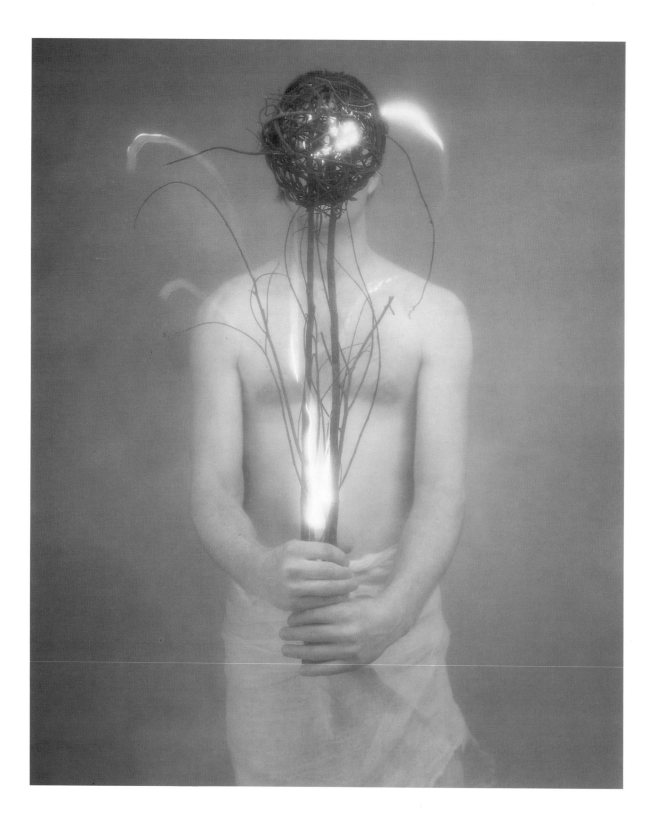

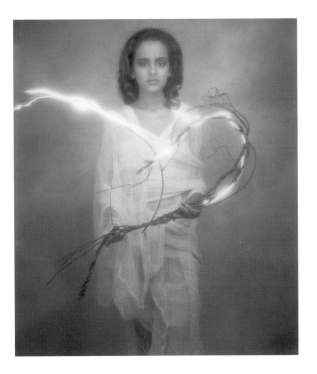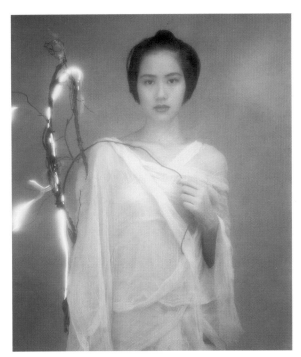

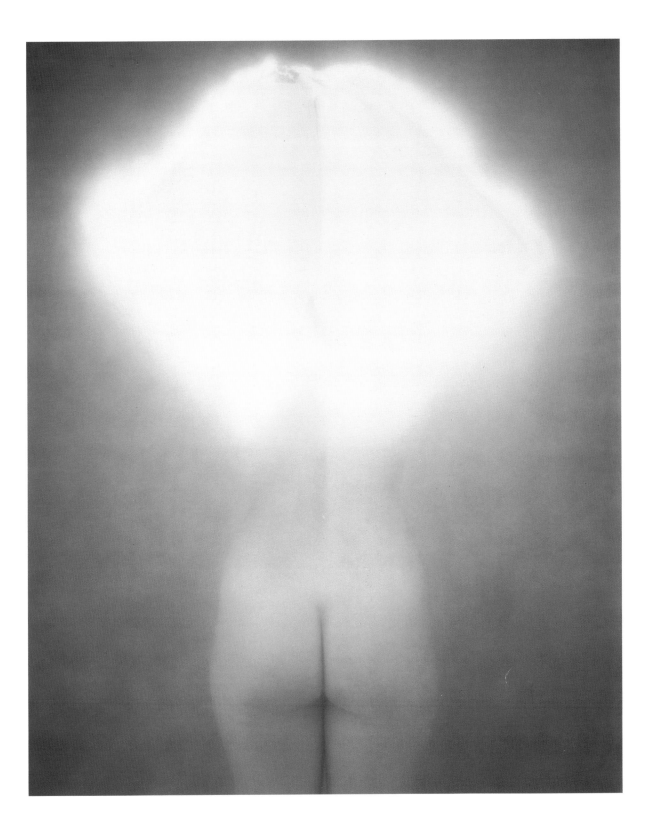

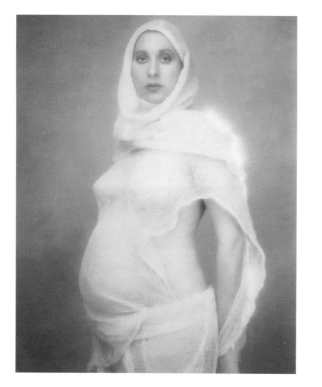 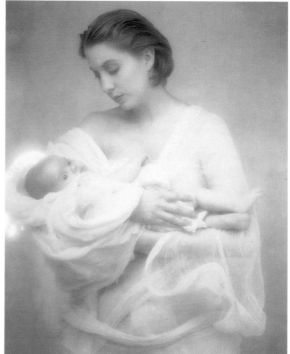

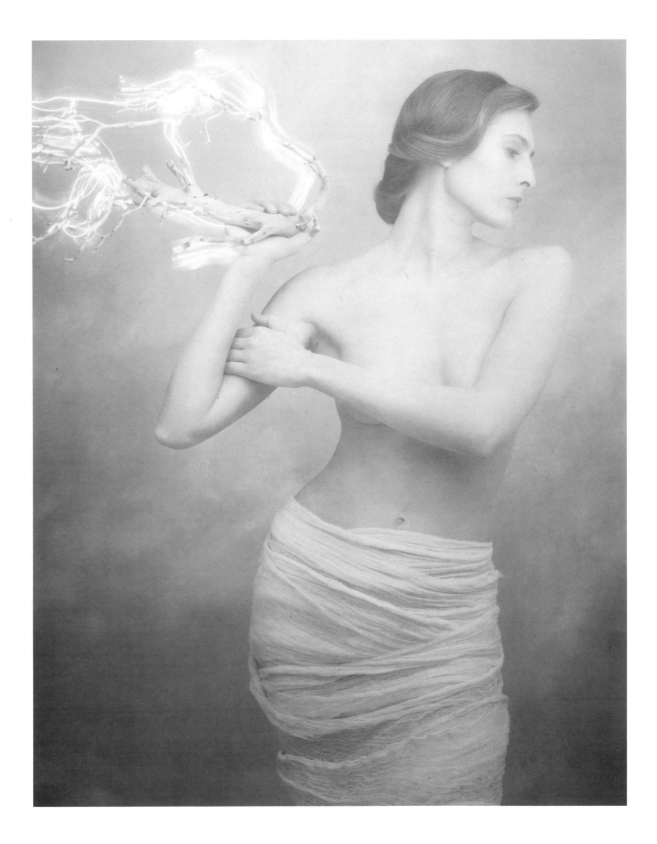

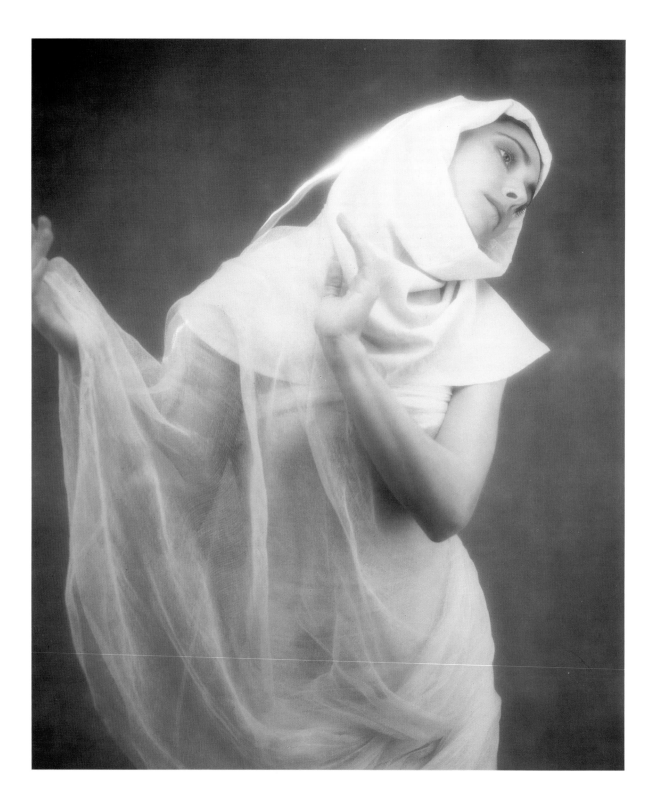

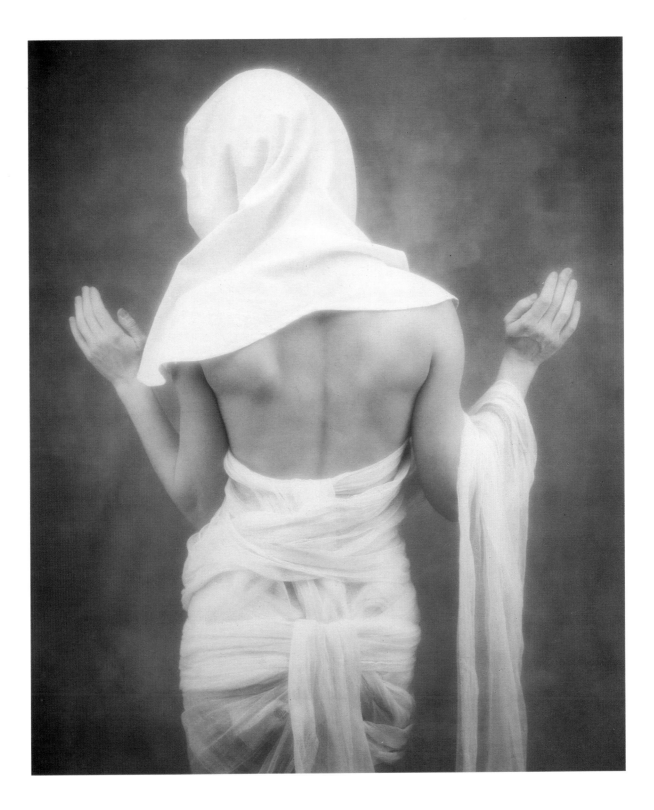

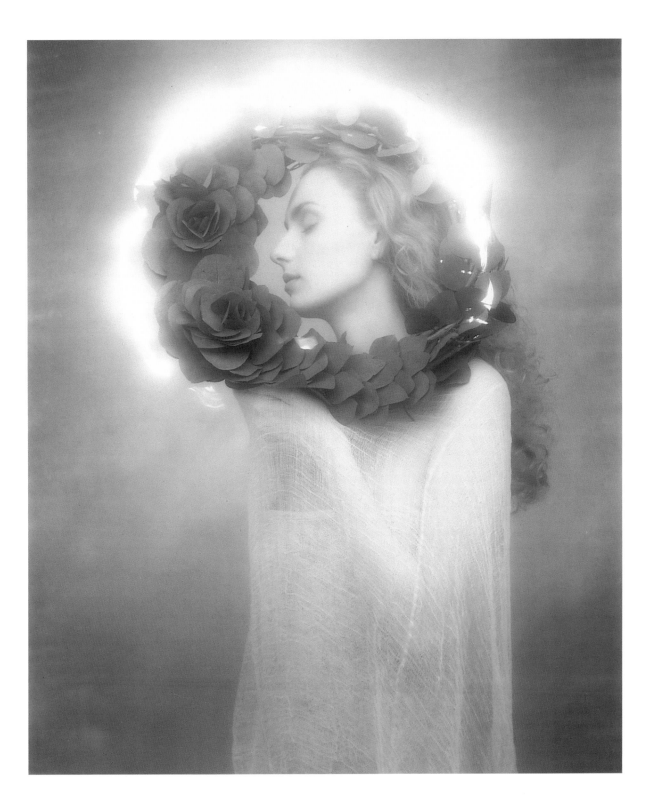

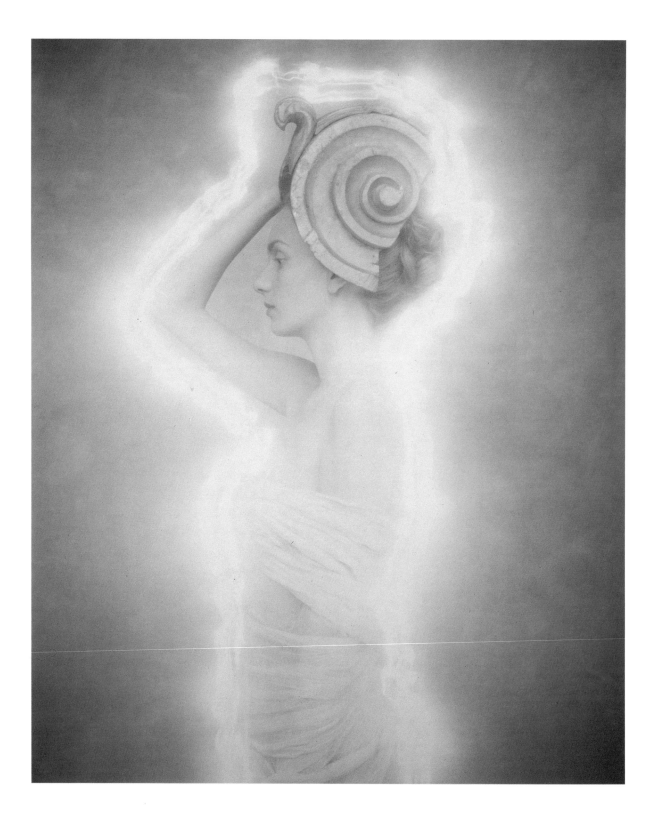

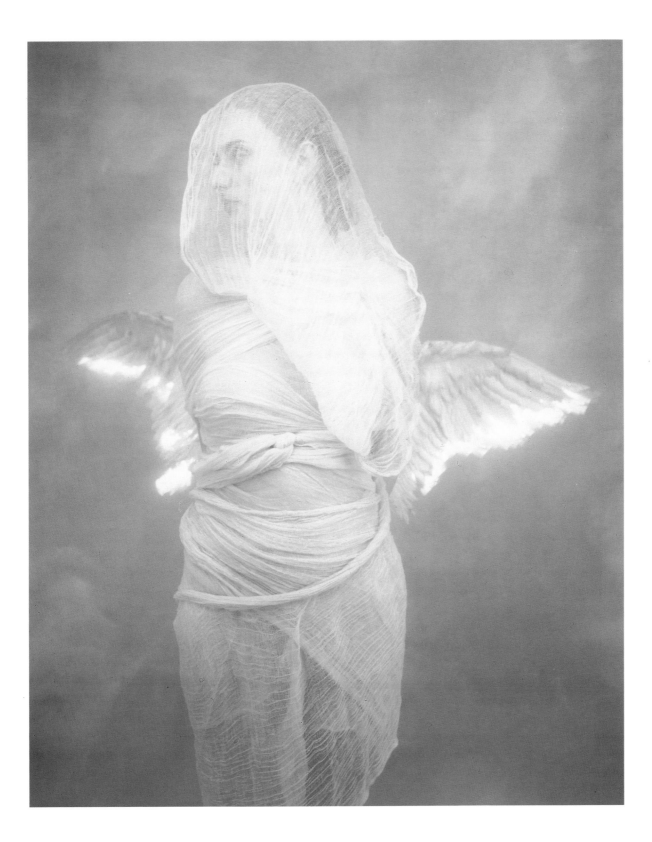

# INTERVIEW

Excerpts from conversations between

## JOYCE TENNESON AND DAVID TANNOUS

DAVID

In many of your photographs, the people seem to be on a search or journey, and often they don't seem to know where they are going. They are found in largely featureless settings, sometimes standing alone in what looks like a swirling fog, and when there are several of them together, they huddle closely, apparently offering each other a temporary refuge along the way. And all we can do is observe and hope they will find their path. Is this imagery a reflection of your own journey?

JOYCE

I've always been determined to follow my vision, no matter where it might lead, and I've always been concerned with the idea of growth—both personal and professional. I feel that my work has evolved as I have grown, and when I give lectures on my work, I sense that the people in the audience feel they are watching a life unfold at the same time they are seeing the process of my work's creation—and its evolution.

DAVID

So in that way your work is a kind of journal or diary. Your photographs are a record of your search — and an aid as you continue. What in your early life moved you to become an artist?

JOYCE

There is no question that the convent where my parents worked was the greatest inspiration. For me as a child, it was a mysterious environment. Looking back, I see it as something out of Fellini—filled with symbolism, ritual, and beauty, and also a disturbing kind of surreal imagery. (FIGS. 1, 4)

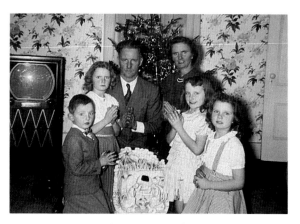

FIG. 1. *Tenneson Family, 1950*

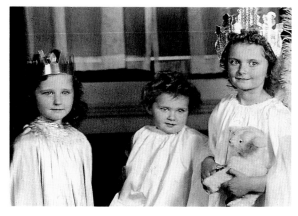

FIG. 2. *Tenneson Sisters as Angels, 1947*

I can still recall the vision of the nuns in their long habits walking down the path to our house to visit us, and the sound of their long strings of beads hitting each other as they took each step. I both admired and feared these strange beings. They lived in a mysterious world of secrets that I longed to penetrate and uncover. So I watched. In a way, I became a voyeur, and this desire to observe everything has stayed with me.

### DAVID

Often, the figures in your photographs are partially covered in long flowing draperies — thin white cloths, sometimes transparent, sometimes opaque — which conceal and reveal at the same time. In the way that in some images these coverings only hint at the underlying shapes of the bodies, they are similar to nuns' habits. Did you ever wonder, when you looked at the nuns, what was underneath all that cloth?

### JOYCE

Of course, we all used to wonder. They were so impenetrable and mysterious. My two sisters and I always were enlisted to be in all their pageants. At Christmas we were angels; at Easter we were in the processions; and on May Day we wore white dresses and flower wreaths in our hair. (FIGS. 2, 3)

### DAVID

You use the word "voyeur." That's a loaded term, and a very interesting one. How do you mean it, and how does it apply to your early life?

### JOYCE

I think I *am* a voyeur, but I don't attach a negative connotation to the word. From an early age I always had a private world — quite separate from the day-to-day world around me. I felt very

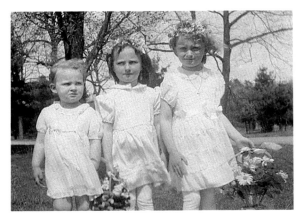

FIG. 3. *May Day Procession, 1949*

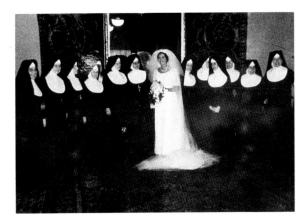

FIG. 4. *Wedding, 1967*

different from the rest of my family, and I read constantly.

DAVID

Early on, did you construct your own world to meet the world of your books?

JOYCE

My favorite book was *The Secret Garden* — the story of a hidden place where you could make things be the way you want them, if you could only find the key to get inside. I liked other books — biographies as well as fiction — that would let me get lost in a fantasy. And I think that quality I found in my reading — of being in another world, a world of imagination, yet surviving in the real world — is part of my everyday existence now, and it has been since childhood.

It didn't come just from books, though. It was in so many parts of my life. For instance, I baby-sat an enormous amount, to make money, and it was for families very different from my own. From the time I was thirteen until I was seventeen, I went away each summer with a different family for two months as a live-in baby-sitter. I watched how those people lived and interacted, and how they decorated their houses and how they dealt with their children. I took that all in, and I learned.

I had similar experiences when I was lucky enough at seventeen to go to France as an exchange student for a year. I lived with twelve different families during that time, from varied backgrounds. This had a profound influence on me. It was my introduction to the whole civilization of Europe — art, philosophy, culture — a way of thinking and living that still is important for me. That trip was the beginning of so many things. It's hard to believe it now, but I had never seen any real art before I went to France.

DAVID

So these experiences of your early life continue to affect you, in direct and specific ways.

JOYCE

Yes, for better or worse. I have an acute visual memory. When some situation hits me strongly, I remember everything about it — where I was standing, what I was wearing, what the other person wore and said and did, and the look on that person's face. I can remember the conversation word-for-word, and even what I was feeling inside. I'm always interested in how other people are, and how their minds work, and how they operate in different circumstances and cultures. Wherever I am, I'm always watching.

It doesn't come from being judgmental, though; it's because I'm very curious. More than that, I'm genuinely

interested. I like people—I love to know about them—and my relationships with other people are very important in my life.

DAVID

Why do you think you turned to photography, rather than to some other way of making art?

JOYCE

I was attracted to photography because it allows me to work with the figure very quickly. Almost all of my work involves the figure. I'm interested in probing the emotions and psychologies of people, and photography is ideal for this. I've always wanted to know what people feel—to get below the surface—and this is probably why I'm drawn to the works of a number of Expressionist painters. Among my favorites are Munch, van Gogh, and Schiele. I identify with the emotional immediacy and poignancy that I see in their work.

DAVID

In much of your work, the figures you show us are partially or completely unclothed. Why are you so fascinated by the nude?

JOYCE

It is something that evolved fairly early. I guess I wanted to keep purifying the figures, to place them outside time, almost like mythic beings. The nudity brings a sense of vulnerability, too, of being unguarded. And that's what I'm really interested in exploring—emotional essences, internal realities, things that are common to all of us.

I try to use the nudity as a kind of window on the psyche, the inner self. I want the viewers to empathize with the openness of the figures, the lack of self-protectiveness, and I guess I'm hoping that they will see themselves there. Yet, some people have trouble looking at nudes.

DAVID

Perhaps because they have difficulty in the kind of self-examination that nudity suggests. The people in your photographs are so receptive—so open and empty of "self"—it's possible to read many different things into the pictures. That ambiguity can be the source of anxiety: it isn't clear what your models are thinking or what you want *us* to think. We're on our own—you refuse to guide us—and that very openness of the figures becomes a mirror.

Another thing—the unclothed figures suggest the possibility of a sensual connection: with each other, if there are two or three people in the image, or, given a single figure, with us. This can evoke nervousness or fear; it can be threatening.

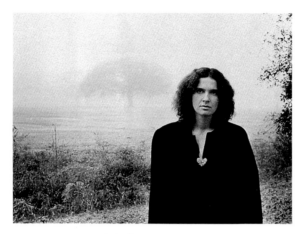

FIG. 5. *Self-Portrait in Fog, 1976*

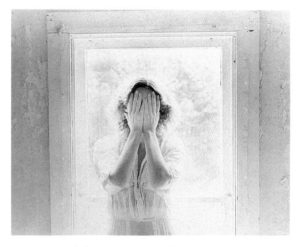

FIG. 6. *Self-Portrait, Hands over Face, 1976*

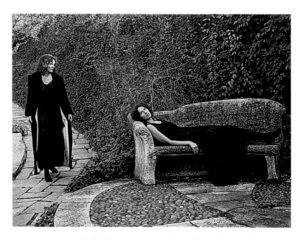

FIG. 7. *Self-Portrait as Two People, 1978*

JOYCE

That's true, but I don't think the sensuality comes entirely from the nudity. The skin is only one of my "raw materials." In many of the pieces, I connect some kind of cloth with the figure, even if it's only a skullcap or a thin scrim-like wrap. I use the fabric to give a variety of surfaces—and sometimes to make connections between the people in the image—and to help show the movement of light. Those are my materials: the fabric, the skin, and the light, and then the inner person I'm trying to reveal.

DAVID

Before you began to photograph these figures, though, you were taking pictures of yourself. Your investigations really began there: in a number of ways, the early photos were a self-discovery. In them, you present yourself in stages—your hands, or your torso, or your figure turned away, or your half-hidden head—almost always in an ambiguous setting, with few references to establish exactly where you are. (FIGS. 5, 6)

In the group of pictures printed in a brushed emulsion on print-making paper, it actually seems as if the images are gradually coming into being *as we watch*, forming themselves out of the milky light. (FIG. 8) And in all of these, it seems that the self which is being discovered is not so much involved in

describing a story as it is in visualizing a state of being. How did you see yourself in these early pictures? What were you discovering as you covered your face or spread your hands to hold a child's dress?

### JOYCE

In this early work—which is now fifteen to twenty years old—I was not conscious of what I was doing: I just had this internal push to go out and make these photographs. I was almost possessed by this need. As time passed, and especially after I began teaching workshops and giving lectures on my work, I became very much aware that the pictures were part of a whole. They were following the path of my life, and they changed as I changed.

### DAVID

One of these works is a kind of touchstone that bears on so much of what we're discussing—the double self-portrait, in which you are walking down a path and discover yourself lying on a garden bench. What is happening in that picture? Why did you put in two of you?

### JOYCE

That image of the two Joyces is pivotal, because I think until very recently I always did feel like two people. (FIG. 7) The Joyce lying on the bench is, in a

way, doing what she is expected to do. There's a resignation about her—she has her specific life duties, the things that "must" be done, like being a good wife, raising a family, having a socially helpful kind of job, and so on. The Joyce walking down the path, though, is my essence—the person I always knew existed, but who was not free then. She's the Joyce who would like to have had a different life, more exotic perhaps. She wants to fly, but she has held back, or maybe has been held back.

Now, after many years of pain, these two figures seem to have come together in my life. This "wholeness" isn't something I could order into existence—it has had to proceed along its own path, and at its own pace. In a way, I knew that was true when I made that picture, and I guess the picture

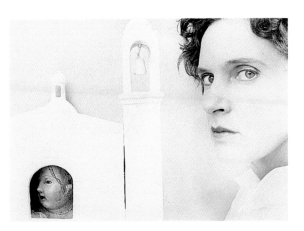

FIG. 8. *Self-Portrait with Church, 1980*

93

was an expression of my hope that it would happen someday. I knew I couldn't force it. I had to prepare myself, and then have the strength to be patient.

DAVID

That picture is like a piece of evidence. The person who made it was aware that something was wrong in her life, but she didn't know how to fix it. What would you tell that younger self if you could speak to her now?

JOYCE

I would tell her what I tell my models, my students, and all my other friends — to believe in yourself and to go for it. There's no other choice, if you want to have a life. You have to go forward and you have to try for what you want. I'm committed to encouraging other people, because it's something I never had. I never had anyone tell me, when I was starting out, "Yes, you are talented. Yes, you have the right to dream about doing this. And you are going to make it!"

As I look back on it, I realize it's almost miraculous that I have managed to break free — to find what I want to do and do it. There are so many people who have things in them that never get out, like my mother, for example. She was very bright, yet she lived a repressed life and then died relatively young without expressing her real talents. I watched all that

happen and I decided not to be a victim. I wanted to make a different kind of life for myself.

DAVID

Why do you think you've been able to do things differently?

JOYCE

Partly it's the times. Before, women were told they didn't have the right to want to have these things. Now, we know we do. Mostly, though, it's finding the courage and the determination, and that's true for

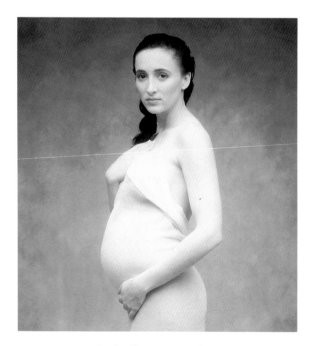

FIG. 9. *Leslie Pregnant, 1987* (see p. 36)

94

both men and women. In my case, another big factor is that I had only one child. If I had had, say, four children, I think it would have been much more difficult to do what I've done in my career.

DAVID

How do you feel about that trade-off?

JOYCE

It's interesting to see how my emotions have changed. I've always deeply regretted not having a daughter, but recently I've begun to feel that I have many children, because I'm working with a number of people who are around the ages my other children might have been. And they're more than just people I work with—there's a closeness that's developed, an emotional connection, a kind of family. I feel very rich in that regard, and perhaps that was my destiny.

DAVID

It's obvious, looking at a number of your pictures over the last half-dozen years since you moved to New York, that you *have* developed a kind of family in your models. The same people show up repeatedly in the images—women, men, and children, singly and together. In an odd way, a group of your photographs is like a family album. And, as with any family, the people you photograph aren't simply your subjects:

they become collaborators. What have you learned from them? What do they give you that you couldn't get simply from looking at yourself?

JOYCE

I think they often become mirrors for myself—I live and relive things through them. And because the emotions and experiences I'm trying to evoke are basic, the images usually resonate with other people as well. For instance, the picture of my friend Leslie pregnant has become one of my most sought-after images. (FIG. 9) People seem to be moved by her strength and self-assurance as much as by her beauty, and at the same time they appear to see the picture as a kind of emblem of pregnancy.

When I took the picture, I was very much aware of thinking back to the time I had my son, Alex: I felt a closeness with Leslie, and a fascination with her experience. I was trying to show something through that photo of her that I could not have recorded fifteen years earlier, when I was pregnant. I simply wasn't evolved enough then. I didn't have the same level of perception, so I couldn't present it as directly.

DAVID

What you've learned about yourself, then, you're trying to show through your models. Do you see in

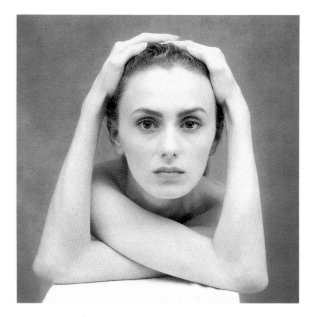

FIG. 10. *Suzanne in Contortion, 1990* (see p. 55)

them aspects of yourself that you didn't recognize earlier, but which now you understand?

JOYCE

Perhaps. Suzanne, the friend I photograph most, said in an interview, "I feel like a medium through which Joyce works. People assume we must have these long discussions about spiritual angst; the reality is that things just naturally happen—we flow effortlessly into each other." That's true, but with her—and with most of the people I photograph—it isn't silent, or solemn. We joke a lot in front of the camera, and sometimes we talk about outrageous things. But most of the time, there is also that deep current between us, a wordless communication.

DAVID

Besides giving you a way to find yourself in them, what do your models offer you of themselves? Does a true collaboration occur at times?

JOYCE

Absolutely. They always give me something individual; if they couldn't, I would not be interested in photographing them. And in some cases, it goes further than that. The way *Suzanne in Contortion* came into being is a good example. (FIG. 10) The day I took this picture, I told Suzanne I wanted to make a special photo just for her—as a gift. I asked her how

she wanted to be photographed; I wanted to know what would give her pleasure. She said, "Do you know I can do contortions?" I said, "Show me!"

She then began to move through a number of body contortions. I stepped back, watched her without comment, and when I saw her twist her arms to frame her face, I said, "Stop, that's it." All I had to do was decide how to isolate that strange configuration. Five minutes later, when I had set up the pedestal and lined up the composition, we took the picture.

DAVID

Does this kind of connection occur more frequently with models you know better?

JOYCE

Yes, although there's no predicting. Another picture that had a similar genesis is the one of Peter holding William. The night before the shoot I had a dream

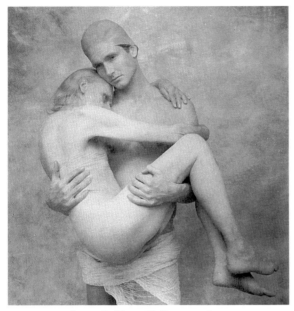

FIG. 11. *Peter Holding William, 1989* (see p. 67)

in which I saw Peter carrying William in his arms, and this image haunted me. (FIG. 11) When I began working with them the next day, I kept thinking about this, but I held back from asking them to try it. I was shy — and this was the "old" Joyce thinking — about asking for something that might be too uncomfortable.

Then, right at the end of the day — five minutes before the studio usually would close — William said, "Joyce, have you ever thought about doing a picture where Peter would just pick me up?" I turned to Peter and he immediately took William in his arms. I said, "Great!" and took the picture, one shot, bang. It was a special moment for all of us. I knew immediately that the picture would have a real power, but I've been surprised — and extremely moved — by how strongly people have reacted to it since. Men especially seem to gravitate toward this picture.

So, you see, there is no formula. I never know what my models — my friends — will bring me in a session, or what I will bring to — and ask of — them. Every day is totally different — that's what makes it so exciting for me. I never know what is going to happen! When I have a particularly great day, when I know I have witnessed and captured things I haven't seen before — special moments — I feel a real high. I feel privileged to record them, and consider them a kind of gift.

DAVID

When you talk about your models, you usually refer to them as your friends. Why?

JOYCE

They are. Most of them have become close friends. We have a shared respect for each other, and also there's an intimacy that's developed over time. And it isn't just in the studio: we see each other socially; we take workshops together; we're always doing things together.

DAVID

How does that closeness — that growing knowledge of each other that comes with friendship — affect what happens in the studio? I know that, unlike many other photographers, you use many of the same people in both your commercial and your fine art

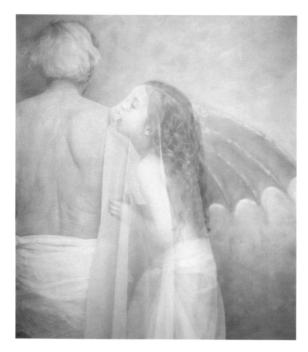

FIG. 12. *Old Man and Deanna, 1986* (see p. 17)

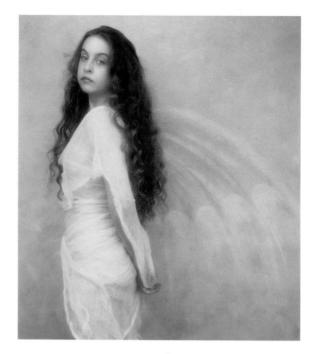

FIG. 13. *Deanna and Bat Wing, 1991*

work. When you photograph them again and again, first for one purpose — to satisfy a client — and then for another — to satisfy yourself — is there a sense of continuity or development in what you are doing?

JOYCE

I had an interesting situation recently with Leslie in a large three-day booking. She was the only model, and I hadn't used her in a major shoot for a while, and she'd been dealing with great difficulties in her life — a separation from her husband and coming to terms with having the primary responsibility for a three-year-old. And we'd been very close through all that, with lots of late-night phone calls and so on. Then when we began to work at the shoot, I saw that she was radiant. She had come through her troubles and she had a new power — a spiritual calm which showed itself in her physical presence.

When I saw the first picture go up on the board, that power was there in the image. I had responded to the change in her, and it had appeared in the picture. I was so moved, I started to cry. I just hugged her and said, "I'm so proud of you, Leslie. You've come out of this in a wonderful way, and I know you're going to be able to forge ahead now." And she will. She will be a big success no matter where she puts her energy.

DAVID

And perhaps your talks with her had been able to provide some of the help she needed?

JOYCE

Yes. And my knowing what she had experienced became part of that shoot. I was reacting to it, and Leslie was responding to my reactions. We were working together on several levels — friends, business

people, artistic collaborators, confidants — and it just built.

We've talked about your models as your friends, and we've also used the word "family," but it strikes me there is another way to think about it. In many ways you're like a film director who has established a repertory company — a collection of people, on both sides of the camera, which you use repeatedly, because you see in them, and they bring to you, something of what you want to present to the rest of us. From picture to picture, they appear in different ways, taking on larger or smaller "parts," changing over time, yet giving continuity and a dense interconnection to the pieces of your work. How about it — have you ever thought of yourself as a potential Ingmar Bergman?

JOYCE

Not yet! But I can see the analogy. Many people have suggested it to me, especially after my slide lectures. And I've always been interested in filmmaking. Certainly I'm fascinated by what happens to my models over time. Deanna is a good example, because I started with her when she was very young. A photo I took of her in 1986 is really poignant for me. (FIG. 12) It seems to speak of life's fragility, and of a kind of lurking violence, which even beauty can't guard against.

Another picture I took in 1991. (FIG. 13) Here Deanna five years later seems to have a unique personal strength. Very calmly, she's standing up to the world; nothing menaces her. I've always loved her face, because through it, I feel, one sees an old soul. I never tire of photographing her.

DAVID

So these two images of Deanna are like fragments from an account of the progress of her life — her growing up, changing, taking on a new assurance. Many of your more recent pictures are like that — parts of an extended but elliptical narrative, with a lot of gaps, given to us to assemble as best we can. It makes me think of those experimental novels in the sixties — loose pages in a box, with each page self-sufficient, yet with references to things occurring on other pages. There was no "right" way to put them together: each reader had to make a different and personal novel.

JOYCE

That's what makes working with some of the same people over and over again so interesting. It isn't just the models, but my whole team, including the group behind the camera. I work with very interesting and talented people. They're with me for long periods of time — they're part of the family — and I very much value what they offer.

For all of them—models, assistants, everyone else—their lives change, year after year. They get married, they get divorced, they have children, they start new careers, and all this is shared. My life changes too, and our changes affect each other. The people I am closest to tell me that they feel a shared giving. It's certainly not just one-sided. They know all about me, too.

### DAVID

There have been striking changes in your work in the last half-dozen years. You have moved from black-and-white to color. The look and atmosphere of the images have changed, and a new forthrightness and assurance have emerged. Your use of light has changed. And all of this seems caught up with two great changes in your life—moving from Washington, D.C. to New York and building a new career.

In Washington you lived with your husband and son in a large house filled with extraordinary things you made and collected. You taught at area art schools to make a living, and you took individual portrait commissions of local business and society figures. Your own photo work was in black-and-white, and you developed and printed all your pictures at home.

In New York you're on your own in a small white loft, more a studio than a living space, with fewer special objects around you. You've become a top commercial photographer, an award-winner, traveling around the world on various shoots, with an entourage of assistants and models. You give lectures and teach workshops all over the country and overseas. You are commissioned by national magazines to take portraits of celebrities. Your own work, like your commercial work, is in color, and you send it out to be processed and printed. That is a lot of changes in a very short time.

### JOYCE

Isn't it! Especially looking back, it seems so, but that's not the way it appeared when I began. I realize now I was in a kind of chrysalis until I left Washington in 1984. I felt that I couldn't have my own life, the life of my visions, because of my family responsibilities—I had to be there for my son, Alex, while he was growing up. So I waited, until he was older and more independent. I made my work and tried to develop and learn about myself—and I put energy into building a beautiful environment around me. Coming to New York was more than just a physical move. It gave me the space I needed to grow, to become myself—in my life and in my career.

It was also one of the hardest things I've done in my life. I didn't know what I would find there, whether there would be a career for me, or even a way just to

earn a living. I didn't have a grand vision of how I would "make it." I just knew I had to try; I had to make the move; I couldn't stay where I was anymore. I felt I was leaping into a void, with no safety net. I was scared. The loft I sublet had rats—I could hear them at night—and I lost so much weight, I looked almost anorexic. For months after I got there, I'd wake up every night with huge attacks of anxiety.

DAVID

How did you look for work?

JOYCE

I spent the days carrying my portfolio around like a college grad looking for a first job. No one gave me any real contacts; in fact, I had never done a commercial job before. All I could show people was my fine art work and some of my portraits. As far as they were concerned, I had no track record. It was nine months of continual rejection before I got my first break.

DAVID

What kept you going?

JOYCE

I did commissioned portraits every weekend to pay for my expenses. It was nonstop work—an agonizing time. But I had always had to depend on myself and keep on going to get what I wanted, so I knew that I wouldn't give up. People ask me now how I made it to the top "so quickly." Believe me, it didn't seem quick then. And I didn't know in advance what the result would be. What I tell them is that having your own style is just openers. You also have to have drive, and an incredible persistence. And it doesn't hurt to have a faith in yourself, as well. I know these sound like clichés, but it's all true.

One other thing that made a difference for me—I've always had good friends. They stuck by me and told me to keep on going. My relationships with my friends are intense and intimate, and having that support and love from them—and from my family—has seen me through any number of bad times.

DAVID

Did anybody in the business offer you any advice or encouragement?

JOYCE

I remember meeting Irving Penn several months after I arrived in New York. I felt lucky to show my work to such a famous photographer, someone who was at the top of the art world and the commercial world as well. After looking at my portfolio and talking to me a bit, he said, "I think you're too sensitive for this New York commercial world. You've got the talent, but I'm afraid you'll get a bloody nose a lot on the way up."

I recall thinking that what I was going to say to him then would be important—for me, if not for him!—so I looked him directly in the eye and replied, "I'm prepared to pay whatever price is necessary." He said, "Well, then, you're bound to make it." I never forgot the image of the bloody nose, and he was very right about it.

DAVID

Your portrait commissions have been a bridge between your time in Washington and your new career in New York. How have they changed since you made the move? Do you still enjoy doing them?

JOYCE

All of that is a complex question. For a while, they were a major source of income, but the commissions by individual clients often gave me problems, because I realized that most of the time those clients would expect to be flattered in some way. I found that very difficult to do, and very compromising. But occasionally I would get someone who would let me probe deeply and show what I found, and then it was a joy.

In fact, if doing portraits meant that I could be totally honest with my sitters, then I would want to do them every day of my life. I love that kind of interaction. That's why I prefer to work with children

now when I take commissions—with them, at least there is an honesty and . . .

DAVID

A lack of expectations?

JOYCE

Yes. I'm really interested in people, but I'm not at all the kind of person who makes easy conversation. I

FIG. 14. *Alex, 1992*

102

don't do small talk! But I love to be with someone and feel a real connection. I think that's one of my strengths. I connect easily with people on an intimate level — if they're willing to allow it — and then they do reveal themselves. They tell me secrets and put themselves at risk in front of me. And that's one of the most exciting things in my life — that kind of working relationship, which also becomes so personal.

DAVID

And what you find about them gets revealed in the pictures?

JOYCE

I hope so.

DAVID

One of the first children you photographed — and

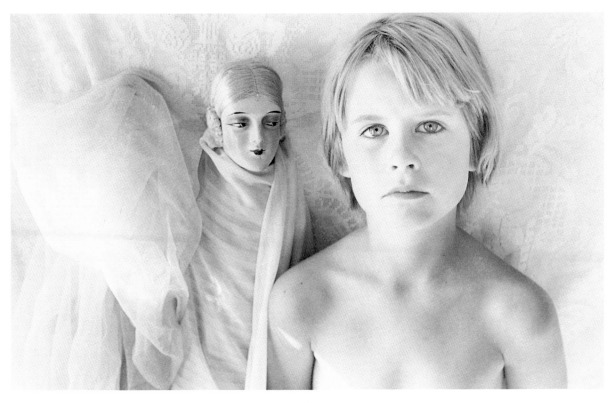

FIG. 15. *Alex, 1979*

103

continued doing over a long period of time — is your son, Alex. Do you still take pictures of him?

JOYCE

I stopped photographing Alex on a regular basis when he was about ten or eleven, because he really didn't like it anymore. But I think Alex was a huge inspiration for me when he was younger: he showed a rare combination of purity and intensity. There was an openness about him that made me feel it was possible to see into him — and through him. Watching Alex grow and become independent has been one of the greatest joys of my life. Recently, I've been able to take some new pictures of him. Now that he has become his own person, there are new things to see, and these photos have become a collaboration between us. (FIGS. 14, 15)

DAVID

How do you approach your portraits now?

JOYCE

For me to feel I'm doing my best work, I need to isolate myself with the sitter and then start probing — asking for everything, without censoring myself.

DAVID

So, you don't want your photographs to be small talk?

JOYCE

No! There has to be more than a superficial exchange going on, and we both have to try to get rid of hidden agendas. That's why I like doing portraits commissioned by magazines now. At least in that kind of situation I have to please only the magazine, not the client's ego. It's less compromising.

DAVID

Can you give an example of one of these magazine commissions?

JOYCE

There was the photograph I did of the actress Jessica Tandy for *Esquire* last year. (FIG. 16) It was part of a big portfolio they published — pictures of American women taken by many different photographers. I had complete artistic freedom, and I made a picture I felt was strong. The problem was that it almost didn't get published.

DAVID

It's an interesting situation. Here you were working with somebody who is famous — with a public persona which has been developed over many years. Moreover, as an actress, she knows how to present herself in a certain way. Yet you were trying to see actually who she is, and to bring out your own idea of how you felt about her. How did that work?

It turned out to be an inspiring shoot, because she was very open. She told me she trusted me — personally and artistically — and that I should just do something I was proud of — so that's what I did. Most people who meet her talk about how strong she is, and I certainly wanted to show that strength, but I was more interested in revealing a poignancy I saw in her, and also a mysterious reserve. And then, of course, her beauty, which is there no matter what she's doing.

So after we talked for a while, I just wrapped her very simply in some loose white cloth. Then I asked her to stand and look back at me openly and very directly. And I took the picture — it seemed effortless.

DAVID

Not a typical "glamour shot."

JOYCE

Not at all. Then the problem became whether the magazine would publish it, because they thought it was "strange" or "possibly disturbing." Luckily, they did, and after it was published, there was an extremely good reaction to it, some very favorable critical attention. Once *that* happened, they were very happy, so in the end everything turned out all right.

DAVID

The commissions, then, can be problematic even when the sitter isn't the client?

JOYCE

The magazines can be hesitant sometimes to publish images they feel are too demanding of their viewers, but I think they underestimate the public. Even so, I enjoy working with them, because usually they let me explore what interests me.

DAVID

Another kind of work you've carried over to your new situation is teaching — or at least an aspect of it. While you were in Washington, it was a full-time occupation. What attracted you to it?

JOYCE

Part of the decision was practical. Most artists now have to find some way to make money to survive and still have time to make their art. It's virtually impossible for them to earn a living by selling their personal work; usually they either have to teach or do some kind of commercial work.

So, early in my career I chose to teach, and I loved doing that, but after fifteen years I found it wasn't satisfying anymore. I no longer felt challenged, and at the same time I was giving too much emotionally,

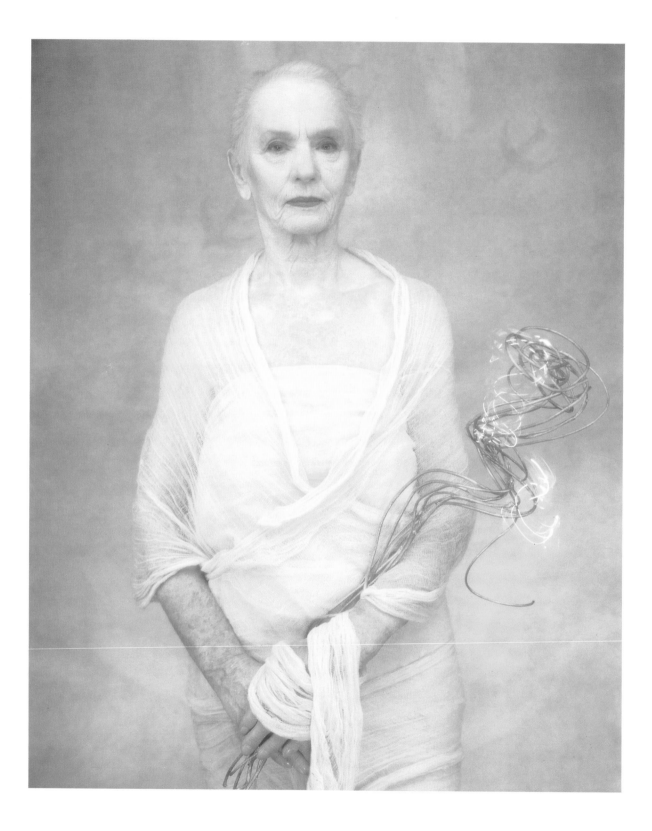

FIG. 16. *Jessica Tandy/Actress, 1991*

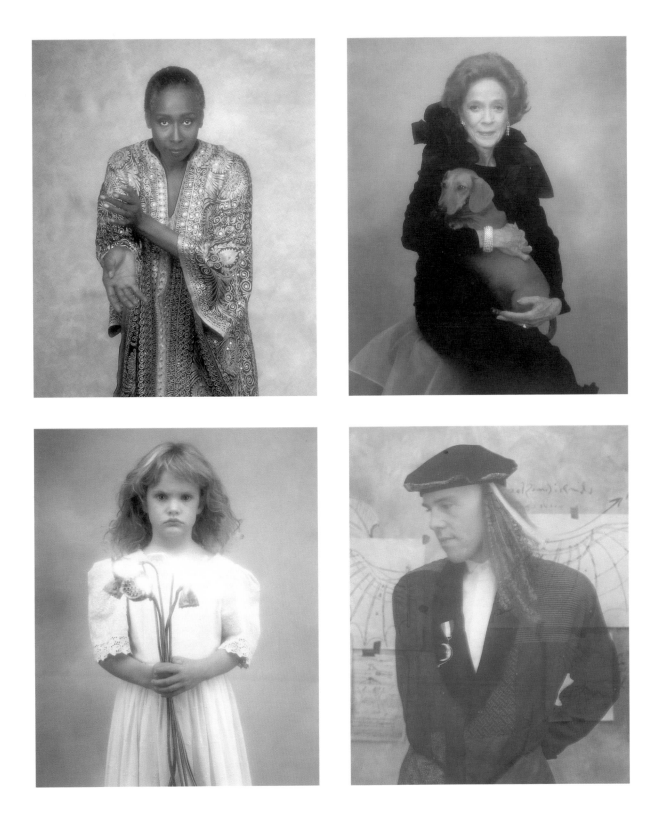

FIG. 17. *Judith Jamison/Artistic Director, Alvin Ailey, 1991*

FIG. 19. *Brooke Astor, 1991*

FIG. 18. *Hallie Baker, 1991*

FIG. 20. *Thomas Dolby, Composer/Musician, 1991*

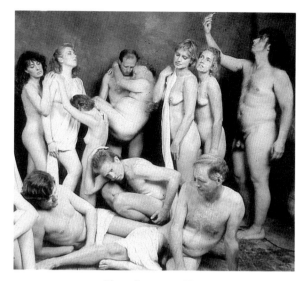

FIG. 21. *Class Portrait, Maine, 1990*

becoming involved with the artistic and personal problems of the students. It strained me so much, I was finding it hard to make time for my own work.

DAVID

Yet you still give lectures and conduct workshops fairly regularly, in many different places. So you haven't completely given up this part of your life.

JOYCE

I doubt I ever will. It gives me a chance to give back something to others, to discuss not only photography, but also what I've learned about life. And then I get a lot out of it, too. That happens regularly in my lectures — almost always people will come up afterwards to comment on what I have shown and to tell me something about themselves — and it happens even more in my workshops, where I have time to get to know the students.

DAVID

What goes on there?

JOYCE

The workshops are a kind of learning lab where the students are encouraged to go within themselves and mine that territory. I function as a kind of catalyst — I help them feel able to risk revealing themselves in front of the group. At the same time, they get excited by seeing the growth of their work.

DAVID

So you help give them the confidence to be demanding of themselves as well as of their work.

JOYCE

Yes, and to have fun too. This is a class portrait done by the people in one of my workshops as a surprise gift to me. (FIG. 21) I couldn't believe it! Imagine all of them — ages twenty to seventy, all shapes and sizes — doing a nude group portrait that pokes fun at and imitates some of my own images. They knew it would amuse me. But beyond that, I think it shows a wonderful opening up — almost none of them had even thought of doing a nude self-portrait before the workshop, much less a group one.

DAVID

With the workshops and the teaching, you seem drawn to involve your inner life in addition to your technical abilities. Does your commercial work allow you to operate at more of a remove?

Perhaps. I think I am more pleased at this stage of my life to use commercial work as my primary money-making activity, because I believe it's the most appropriate solution now to that problem of survival. I feel that I'm in the front lines on this, along with a lot of other artists. In the past, doing anything commercial was really disparaged in the art world, but this is no longer the case. I know that working commercially in the past seven years has made me grow more, professionally, than teaching ever would. I came to the end of the line with my teaching in a certain sense.

DAVID

There are other artists currently and in the past who have used commercial work as a way to make a living, but for most of them their commercial work has been quite deliberately distanced from their fine art activity. An example is Edward Hopper, who for years did advertising work which was perfectly competent but had nothing in it that said "Hopper." That's not what you have done, though, and in a way the method you have chosen has put you much more at risk.

From the beginning, your commercial work has resembled your fine art work. Not only do you use many of the same models, but also you create a similar setting, atmosphere, lighting—a "look." Yet there is a difference between the two. They are made for different purposes and under different constraints, and they are different in effect. How do you maintain that difference within the similarity, and how do the two kinds of work touch on each other?

JOYCE

I think that the real difference is that my commercial work very rarely has the psychological edge of my personal work. There isn't that haunting strangeness, or upsetting quality—to use some of the words that have been applied to my work.

DAVID

Why? Is it because of what you want?

JOYCE

It's what the clients want. They want something pleasant and beautiful, and perhaps a little bit unusual—but not too "strange."

DAVID

It's paradoxical. You mentioned that when you were first looking for commercial work, you used your fine art photos as your portfolio. So those first clients signed up to get the feeling of your personal work. Yet apparently what they didn't want, and what most of your clients don't want now, is what gives strength

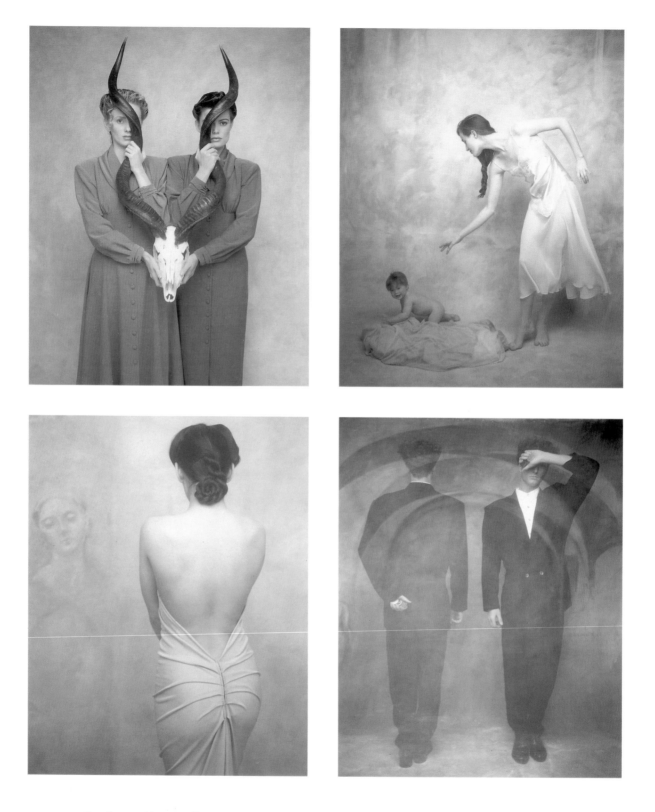

FIG. 22. *Catalogue, Glenn Williams Design, 1988*

FIG. 23. *Giorgio di Sant'Angelo, Designer, 1988*

FIG. 24. *Dayton-Hudson Catalogue, 1991*

FIG. 25. *Glenn Williams Advertising, 1988*

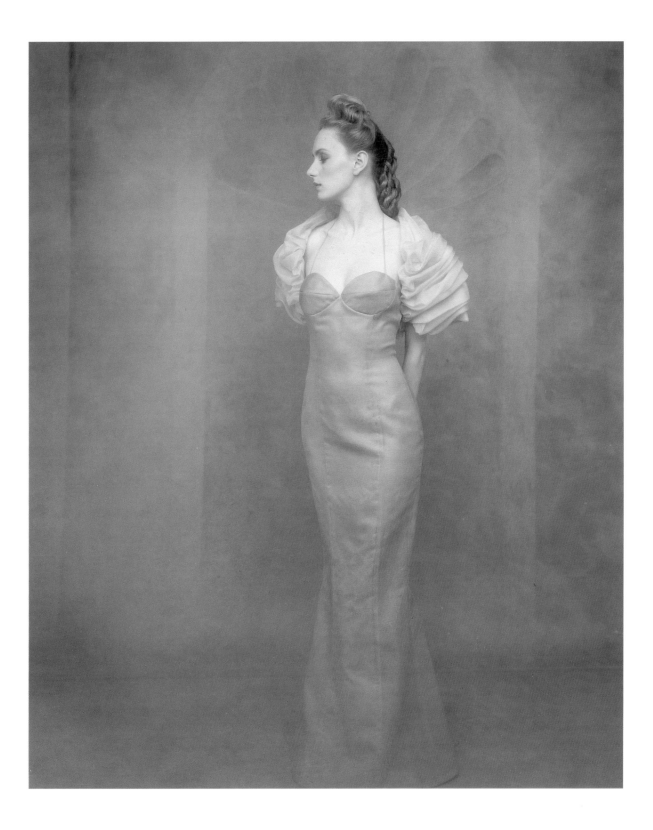

FIG. 26. L.A. Style *Magazine Cover*, 1989

to your fine art work — the mystery, danger, perhaps the melancholy. They want the qualities of your personal work, but "vaccinated," as it were.

JOYCE

Exactly! Vaccinated, and safe! They don't want anything ambiguous or, heaven forbid, "weird." I realized this in 1985, when I was just starting to break into the commercial world. I remember one nervous client taking me aside right before a shoot and saying, "Remember, no death or dying, nothing disturbing . . ."

DAVID

How do you feel about that?

JOYCE

It's the price I pay for my financial freedom. That's why I make a very clear separation in my mind between the work I do for myself and the work I do for clients. Before coming to New York, I wrote in my journal, "I'd like to bring a sense of the spiritual into the world of commerce." And every once in a while — happily — there's a crossover, but most of the time the commercial work lacks real depth. It's what the clients want, but it doesn't have the edge I value.

DAVID

And yet you feel it succeeds on its own terms?

JOYCE

Yes. For the client's purposes it succeeds, sometimes extremely well, and I find no compromise in doing what needs to be done — within limits. And I always try to give them something of my own vision, as much as they will accept.

DAVID

Do you ever have clients that let you go further?

JOYCE

Infrequently, and they're usually Japanese or European. American clients tend to be more conservative, and more fearful of a negative reaction from their public. It's the same as with the magazines. Early on, I understood what the ground rules were, and I knew that if I were going to expect to make a living at commercial work, I had to play the game. But as a professional I have always turned down work that I have found objectionable. That I do, and fairly frequently.

DAVID

When you do accept an assignment, what leeway is there?

JOYCE

I try to work with the client to problem-solve. I try to find ways to give them what they want — and it's

usually a "them," a group of nervous people, each with a different idea of what should be done and how to do it. At the same time, I'm trying to find a solution that satisfies me.

DAVID

It sounds like a real circus.

JOYCE

Sometimes it can get unbelievably difficult. At other times, it works out well. For example, this picture was done for the cover of *L.A. Style* a few years ago, and it also appeared on the cover of *Graphis* magazine. (FIG. 26) Yes, the model is Suzanne, and yes, it looks like my work, but Suzanne's wearing a designer dress, and the picture is about the dress more than it is about Suzanne or me. I'm proud of the picture, though, because in the context in which it was made, it works very well. It just doesn't have the kind of intensity and inner examination of some of the other pictures of Suzanne I've taken. And that's okay — that's not why it was made.

DAVID

Have you been able to persuade clients to accept your ideas on a fundamental point?

JOYCE

Yes, if I make a good enough case. And especially so more recently, as I've gotten better known and have won more awards. One of the best examples of this, though, is from several years back — the Kohler bathroom picture.

It was a situation where they had a campaign — the great photographers shoot Kohler — and I was maybe the sixth or seventh photographer coming in, and they already had a concept: Joyce Tenneson's intimate bathroom scene with mother and child. But they wanted to cast a blonde as the mother, because they thought it would sell better, and they were going to have some unrelated baby that they thought was photogenic.

At the big pre-production meeting, I spoke up and said, "Listen, if you want me to create intimacy, don't tie my hands behind my back by giving me a nineteen-year-old blonde who isn't a mother, and some baby she doesn't know. Let me use a real mother and child." And I told them I knew the perfect pair — Leslie and her baby, Teo. (FIG. 27)

So they let me go with it, and it's obvious in the picture that those two people care for each other. I know *that* is what is riveting about the ad — the real connection between the mother and the child. And I've been told this ad has been the most successful one in their whole campaign. They have been running it for years.

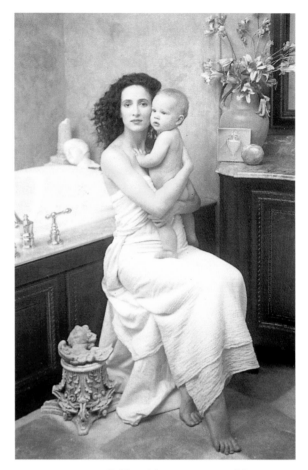

FIG. 27. *Kohler Advertisement, 1988*

As much as anything else, I am trying to give a visual form to the intangible relationships in life that are so powerful. Often these are between people — as you can see in the relationship between Leslie and her baby — but they also can be between people and objects, or rather people using objects to focus attention and discover things within themselves. And then to give some idea of those things to the viewer.

DAVID

Several of your pictures use a mirror in this way, or plant forms or a shell or an egg. And there are the many ways you bring in pieces of cloth — shrouding the figure, or suddenly revealing it, or even giving it wings.

DAVID

So you really had the right idea, and the clients could measure how right you were by looking at the bottom line.

JOYCE

Yes, that picture certainly met their needs, and it was successful on my terms, too. Even so, I wouldn't exhibit the picture in a show of my fine art work — it was made to sell a product — but it's a lot closer than some other examples of my commercial work. The reason for that, I think, is that it touches on something of great importance in my personal photos.

JOYCE

Exactly. The challenge is to find a way to present the inner journey, the self-discovery. It's something of an impossibility, of course. I'm trying to make visible something which by its nature can't be seen.

DAVID

So you're trying to make your own "equivalents," so to speak.

JOYCE

Yes, but not just in the props or the settings. I want to reach into the faces and bodies of my people — to

penetrate them—and find what they are. A nice, easy task, right?

DAVID

Right. I think there has been a change, though, in the way you're going about it. As I look at the more recent pictures, I see something quite different from the photos of even a few years ago. In the earlier pieces, the figures often are turned away from us, wearing downcast looks or abstracted expressions, with bent or slumping bodies, in postures of resignation and submission, or even something that could be interpreted as despair. Now, your people are forthright and self-assured.

They engage us directly, with calmly challenging expressions and sometimes a kind of Mona Lisa smile. The settings are brighter than before; the luminescent fog seems to have been supplanted by bursts and glows of light. These figures carry a sense of power, self-certainty; they seem to have found their desired place. Even if I hadn't known anything about your life, in that progression of your photographs I would find a wealth of inadvertent autobiography.

JOYCE

I think that's true. I do feel very different now than I did even several years ago—part of it is a burst of incredible excitement at being really free. I've had a hard road getting where I am, but I feel I'm in a very good position now, in many ways. Of course, someone could look at my situation and say, "My God, she's a middle-aged woman on her own, living in a crack neighborhood in New York City." As much as to say, "It's the pits."

But the way I look at it is that I have a whole new life, and I feel young enough—in spirit—to enjoy it. And because of that, I also feel incredibly privileged, and some of that feeling may well be coming through in my photographs.

DAVID

The most recent work seems to take it even a step further. You've begun to "draw with light." The people in these photos are bordered by glowing lines of light. In some cases there is a halo-like effect; in others, the lines are almost readable, as if they were a scribbled calligraphy in an unknown language. Where did these works come from?

JOYCE

These pictures with the "light writing" seemed to emerge when I finally realized, with a shock, that I had become free in a way that I had always longed to be. I had been in New York for a while, struggling to get established in the commercial world, and at the

same time pushing myself to go more deeply into my personal work. And suddenly I realized that it was all coming together—that at last I was, in most ways, where I wanted to be. Not that everything was perfect, or that all my struggles magically were over, but that I was moving on my own path and caught up in a struggle that was right for me—one that was helping me to find what I needed.

Knowing that I am finally on my own true path is one of the most important things that has happened in my life. There are times now I feel such clarity, as though I am connected to an inner light of knowing or wisdom. I think it's something we all have within ourselves but have trouble finding.

DAVID

Or don't recognize.

JOYCE

Exactly. We have to learn how to reverse the years of conditioning from family, school, church—whatever—that may have created self-limitations and fears. All my life thus far seems to have been building up to this awareness. For the first time, I feel I am headed down a path that is wholly mine.

Like so many others, I have spent time going down so many false paths—success, making money,

searching for "the" relationship with someone, and so on—when I knew deep down these things never bring long-term joy just in themselves. Only going on the journey to find and connect with one's deeper essence does this.

DAVID

Is that something which can be described in words, or is the visual image the only way you can approximate that feeling?

JOYCE

I know that many mythologies deal with these issues, and many universal myths are about finding the path of enlightenment. In these stories, there is a yearning for transcendence of some kind, an arrival at an enlightened state.

DAVID

It's interesting you use the word "enlightenment." In the new photographs you are making physical the kind of light that you are talking about metaphorically, in terms of discovering what is inside you. Is this a new feeling for you?

JOYCE

Yes, because it's a process that is partially out of anyone's control. You can help set the stage by desiring this awareness, by reading, by meditation, or any

number of things, but ultimately I think it's something that you are suddenly "gifted" with, a kind of grace.

DAVID

This is similar to the way you've described how your best photographs are made.

JOYCE

Yes. I've always felt that I can count on doing very professional work, but that occasionally I come into contact with a kind of force that cannot be willed. Many artists talk about these "magic moments." I remember reading in particular a couple of interviews — one with Federico Fellini and another with opera singer Beverly Sills — in which they each discussed how these moments could occur mysteriously while they were making their art. Without warning or expectation, everything came together, and the result was something extraordinary. Everything they had hoped to achieve was realized, and then it all was raised to an unguessed-at higher level. That has happened for me at times — it's an indescribable feeling. Even though these moments are ephemeral, the memory of them keeps me going for a long time.

DAVID

Along with some of the other changes we've been discussing — in your life as well as your work — and

connected to them in a way, is another significant change. Until you moved to New York, all your work was in black-and-white; in fact, you were known for the unusual effects you got in that medium. Now you work only in color. What made you change?

JOYCE

The black-and-white tied me to the darkroom, because I felt I was the only person who could print the way I wanted my work to look. I think that not only was I in a chrysalis in Washington for all those years, but also I was a slave to the darkroom. And bursting out into New York got me out of confinement, out of the darkroom, and into color. Now I can send my film to the lab and get what I want. The keyed-down range of color I use — it's almost monochromatic — is so pleasing to me, that I don't need the black-and-white anymore. I really identify with the color now — it seems to be a natural extension of what I'm feeling.

DAVID

In the first of your works in color, the tonal range is fairly limited, along with the intensity of the hues, but in the most recent works, where you bring in your "light writing," the colors are more pronounced and there's much more of a contrast between light and dark. How did that come about?

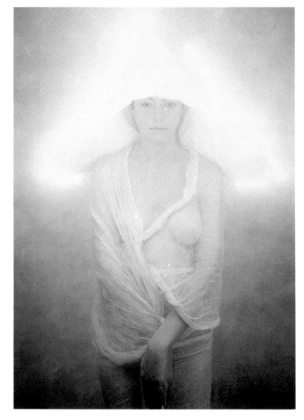

FIG. 28. *Woman and Light Hat, 1991* (see p. 69)

JOYCE

That's a good question. When I show slides of my new work now in my lectures, I have those images at the very end, and I say that the "light writing" is really my coming out of a dark tunnel. I'm finding a new involvement in color as well as a new brilliance in the light, and my new pictures get their effect with the color as much as with the magic of the light.

DAVID

Technically, how are the "light writing" pictures made?

JOYCE

I use a fiber-optic laser. I take an initial exposure with my regular studio lighting, and then I turn the lights off and step behind the figure with a light wand, and I put the light anywhere I want. But it's also enormously unpredictable, and that's part of the fun of it — I can control it to a certain degree, but I can never do the same thing twice.

DAVID

It's like drawing pictures in the dark with sparklers on the Fourth of July.

JOYCE

Yes, except that in the finished works, I'm drawing pictures in the light!

DAVID

And by doing so, literally you're putting the evidence of your hand in your work.

JOYCE

Not only my hand — *I* am in the pictures.

DAVID

What do you mean?

JOYCE

It's hard to find the right words, without making it sound ridiculous. Yet it's what I feel. I'm very interested in the way love emanates from one being to another, and I'm interested in people who have

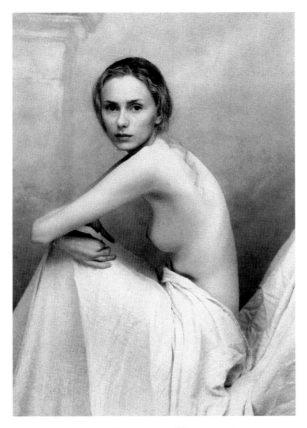

FIG. 29. *Suzanne, 1986* (see p. 15)

developed themselves to the point that when you're in their presence, you feel love emanating naturally from them. It's a very wonderful experience being around people like that. I've been fortunate in that Elise, my closest friend over the past fifteen years, has evolved to this level, and she has been a great inspiration to me.

DAVID

Is this something you're trying to develop in yourself?

JOYCE

It is. I work on it every day. I do meditation, and I try to connect with my higher self. I try actually to envision that higher self and ask questions of it, and

when I envision it, it's very much like the woman in this photograph — the woman looking out at us, wearing a kind of triangular headdress of light. (FIG. 28) She's somebody surrounded by light, and the whole atmosphere is pulsating with light, and it's like a picture of pure energy. So when I take my pictures of figures like that, they seem like friends. These are people I've already seen in my mind — different manifestations of a higher self. Yet the pictures are not direct translations of that inner wisdom or inner light; they are metaphors.

DAVID

How would you compare these new pictures with the ones you took before? Are the differences related to the changes you've discovered in yourself?

JOYCE

I think I've evolved to another level, and it comes out in the new pictures. But I don't want to make a value judgment — to say that one group of photographs is better than the other. For instance, look at the photo of Suzanne on the cover of *Au-Delà* — the book of my pictures published in France in 1989. (FIG. 29) That's a picture I took in 1986 — it was the first photo I ever made of Suzanne — and from the time it appeared, for some reason or another, it has continued to have an enormous hold over people of all sorts — men as well as women, of all ages, and from many

different cultures. It has something powerful about it, and of all my photographs so far, it seems to have provoked the most reaction. It's been on so many magazine covers, I've lost count. Yet, if you were to compare that picture with a strong recent one — the woman with the hat of light, for example — I couldn't say which is better.

DAVID

Which one connects more with you?

JOYCE

I think the one with the light connects more with me now, but that isn't the me of 1986, and I couldn't have taken that picture six years ago. The light in that picture is a metaphor for what has happened to me since then.

DAVID

Not only that, but as I look back over your work, I think it's evident that throughout your career you have expressed the various aspects of your searches in terms of light. (FIGS. 30, 31)

JOYCE

It's interesting how that has stayed. I've changed, and my pictures have changed, but that concern with light has always been there. I've come to realize this as I've put together my lectures on the progression

of my work, and it's very clear to me now that this latest work refers back strongly to that earlier black-and-white work, which has a pervasive sense of inner light.

DAVID

The difference is that the earlier light tends to be subdued — the world as seen from inside a translucent enclosure.

JOYCE

Which would certainly mirror my life at that time. But now the light is there in a new way. I'm thinking about the companion piece to the light-hat one we've been talking about. It's a nude woman taken from the back, and she's got that same hat on, and it's glowing. (FIG. 32) It's almost burning — on fire. She seems bathed in light, transcendent. And there's an

FIG. 30. *Dress and Shells, 1981*

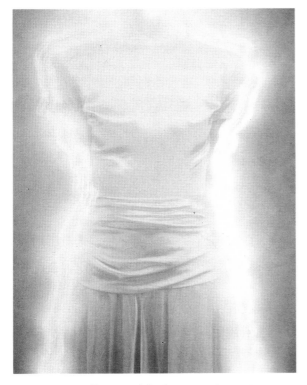

FIG. 31. *Dress and Light, 1991* (see p. 85)

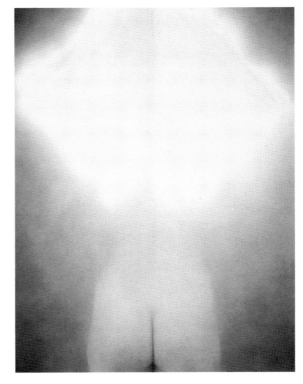

FIG. 32. *Buttocks and Light Hat, 1991* (see p. 77)

enormous sense of freedom in the idea that someone can be nude and transcendent at the same time.

DAVID

A channel of energy.

JOYCE

Yes. And it's almost a sacrilegious concept in a way, especially in our repressed society. Nudity isn't usually connected with thoughts of transcendence or the spirit, but in my work, I think it is.

DAVID

Well, think of William Blake. So many of his figures are either nude — and bathed in light — or clothed in the same kind of translucent drapery which appears so often in your work.

JOYCE

I'm a great admirer of Blake's — his poetry as well as his art. I feel a kindred spirit with him. And there's also his attachment to angels — he writes that he often saw and spoke to them. Throughout my work there's a recurring motif of wings — it's been an ongoing preoccupation.

DAVID

That's part of a number of metaphorical references in your pictures to flight. I remember visiting your house in Washington and seeing wings everywhere — not just in the photos but also in the various kinds of stage settings you constructed with the furnishings and objects in the rooms. (FIGS. 33, 34) I recall in particular that gigantic winged swing in the foyer, in which you could actually take a ride.

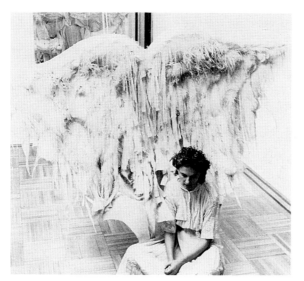

FIG. 33. *Joyce with Winged Swing, 1982*

JOYCE

Yes. I see now that the fascination I have had with wings—in my life as well as my work—has been involved with the idea of freedom. And I think that, with this more recent work, I've come to an awareness that an angel is not necessarily a magical, separate entity out there, in heaven or wherever, as most of us were brought up to believe, but is perhaps just another state of consciousness.

The angel is a potential part of each of us—it's basically our higher self—and as we come into a dialogue with that inner wisdom or higher self, or whatever you want to call it, it allows us to understand this. It's a possibility for every person, but it's most visible in people who have done a lot of work on themselves—who have pushed themselves to grow in consciousness. All the people that I'm close to in my life are involved in that same kind of quest.

DAVID

How have you pushed that growth in yourself?

JOYCE

It's a daily kind of task. Besides the meditation, it's important to stay balanced. I look at my life all the time, and I'm constantly trying to come to terms with what I don't like about it; then I'm trying to change. It's a progression towards making it more of what I want.

DAVID

Do you find that you meditate especially before an important project?

JOYCE

Yes, I do. Before I shoot, I get up early, very early, and usually I'm very anxious—which is a good sign, because if I'm not anxious it means that I'm just going to repeat myself. I meditate, empty out distractions

FIG. 34. *Living Room, Washington, D.C., 1982*

and try to center myself, and I try to think — to run through my mind things that I'm interested in doing in the shoot. I really try to walk into the setting as prepared as I possibly can be — both personally, through my work on myself, and professionally, for what needs to be done that day.

DAVID

Then, once you've made that preparation, do you find that you are ready to respond to whatever unforeseen thing happens?

JOYCE

Absolutely. That's also part of being personally balanced and centered — only then are you ready to respond to the accidents.

DAVID

Is this difficult for you to do — the balancing, emptying, centering? How long has it taken you to learn how to do it?

JOYCE

About ten years. I think in the last few years, though, I've gotten much better, and it's only been since then that I have had a relationship with my higher self, and that helps guide my entire life. But, I'll tell you, it's hard to hold on to any deep sense of stillness and beauty in New York City. My block is filled with

cement parking lots, twenty-four-hour "adult" video stores, drug pushers, and horns that seem to blow nonstop! Sometimes I think I'm living in the Theater of the Absurd.

DAVID

Did you have to overcome any reluctance to start this path of investigation? Initially, did you wonder whether this was some kind of hocus-pocus activity?

JOYCE

Not at all. I'm convinced that our whole culture is changing and growing in this direction, and that there is an incredible movement toward an increased spiritual responsibility. Every time I give a lecture, I get a great feedback from people — all sorts, both at the lecture itself and afterwards in letters. They tell me how excited they are to watch somebody's work reflect these kinds of concerns. This movement to understand ourselves and our place in the world is one of the most important questions of our time. Our whole consciousness is changing, and I think it's a very exciting time to be alive.

DAVID

As you talk about your own search, repeatedly you bring up the concepts of flight, freedom, and light. How do they connect?

JOYCE

I think they've always been connected for me. I began to realize it a few years ago, when I was working to come out of a depression. I was looking for that quiet place in my meditation, and I developed the goal of achieving inside myself a light. This is what really pulled me out of the darkness — knowing that I didn't need some outside force to bring me that light, but that I must have it within me, and once I felt I could find that within myself, then I was free.

I realized that this was a source of sustenance I could really trust — it was within me, and it wouldn't fail, like outside sources. I knew I had good friends who would be there for me, but I also knew that, in the end, I would always be alone, and once I realized that I could survive by myself because I had found that connection with the higher self within me — the light — then I was able to go forward with less fear.

DAVID

Does your higher self still appear to you primarily as light?

JOYCE

Yes. I do relaxation techniques that allow me to become quiet very quickly, and when I'm in a quiet state, I feel it as a vibrating light inside me — in a way like the light of the new photographs. I see the vibrating light, and if I have a simple question about something bothering me, I'll ask, and I'll get an answer. Sometimes, if it's a more intricate question, like what I should do with relationships in my life — where there isn't a quick yes or no answer — what happens is that I'll have a dialogue with this person — the light — almost like the one I'm having right now with you. It's like asking for guidance, and then being quiet to see if guidance comes.

Sometimes it doesn't, right away, but it comes later. I remember once this last winter when I had a particularly tough decision to make, and I just couldn't seem to get any clarity, I was watching a movie, and all of a sudden the answer came. It just flashed in my head, like a neon light, and I knew it was the right decision.

DAVID

So that inner light has become a guide.

JOYCE

It has, very much. Coming out of that bad time, once I realized I could find that light within me, and it could be a sustaining force regardless of what happened with the relationships in my life, then I felt I could fly. It was the ultimate freedom, and it manifested itself in this aura of light.

DAVID

And you wanted that to be in your photographs?

JOYCE

I thought at first that I wanted actually to have
writing in my new works, to have recognizable words
be a part of the images. One phrase I wanted to use
is "spiritual warrior," because in a way I feel like a
spiritual warrior.

DAVID

What do you mean?

JOYCE

That the important thing for me is to continue a
spiritual exploration, no matter where it leads, or
how difficult it gets. And that if it takes a struggle,
I'm prepared to fight whatever gets in the way —
other people's hindrances, my own fears and
mistakes — so that I can keep on my path.

So I wanted to use those words, and take other
snippets and phrases from my journals and put them
in the photographs. I experimented with taking
a picture and simultaneously writing in it with a
flashlight, and what I realized, after one whole day of
working with it, was that I was already writing with
my pictures. I was already speaking with the light,
so why did I have to write the actual words? Why

couldn't I just take a picture of the light? So I made
a picture of a figure with a line of light, and that's
when it clicked.

DAVID

Do you think that light will stay in your work? Do
you have any sense of what kinds of pictures you will
be taking a few years from now?

JOYCE

Well, I see some clues and I have a few intuitions,
but basically it doesn't matter. I'm more interested in
enjoying the journey, because I have learned that the
most important things in my life are the events of the
process — what has happened along the way.

I feel very fortunate to be alive now, at the end of
this century, because we all have more opportunities
to live different lives than ever before. We can fulfill
responsibilities in one phase of life, and then, with
the right energy and drive, we can go down new
paths which have presented themselves. I don't know
exactly what I will find in front of my lens next. I
only know that I will try to be open to whatever new
comes along. It will be interesting to see . . .

The conversations from which these excerpts are taken were recorded
in late 1991 and early 1992 in Washington and New York. The excerpts
from the transcripts were selected and edited by David Tannous.

# LIST OF PLATES

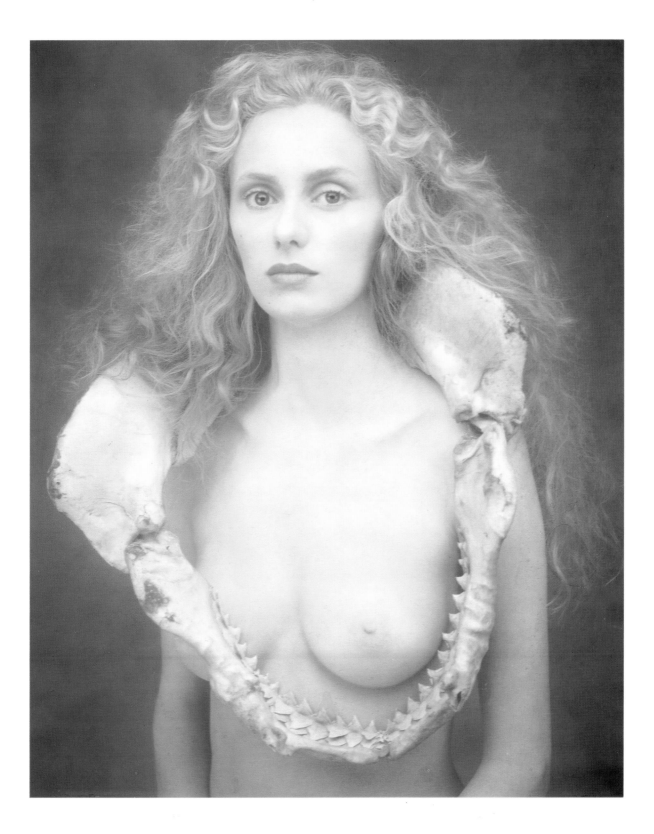